IMAGES
of America

MICHIGAN CITY

D1599237

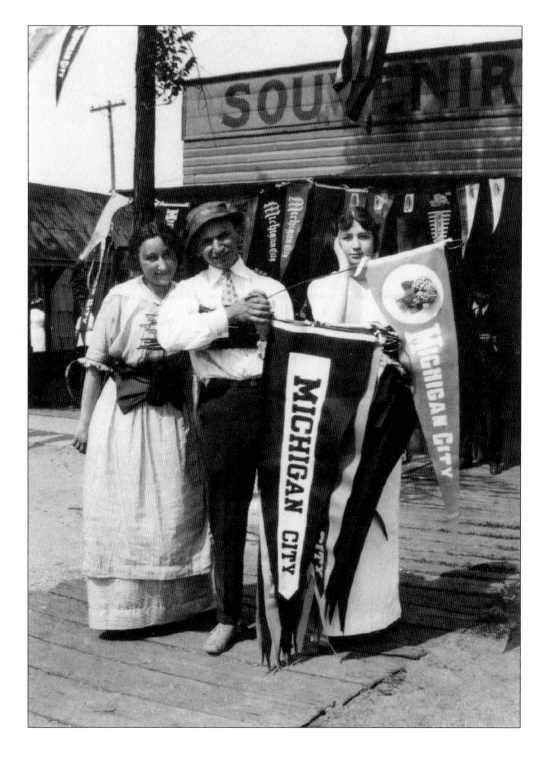

IMAGES
of America

MICHIGAN CITY

RoseAnna Mueller

ARCADIA

Published by Arcadia Publishing
Charleston SC, Chicago IL, Portsmouth NH, San Francisco CA

Printed in Great Britain

Library of Congress Catalog Card Number: 2005921103

For all general information contact Arcadia Publishing at:
Telephone 843-853-2070
Fax 843-853-0044
E-mail sales@arcadiapublishing.com
For customer service and orders:
Toll-Free 1-888-313-2665

Visit us on the internet at http://www.arcadiapublishing.com

CONTENTS

ACKNOWLEDGMENTS

This book would not have been possible without the skill, advice, and technical assistance of Robert Mueller, my husband and the coauthor of *LaGrange and LaGrange Park, Illinois* (1999) and *Harbor Country* (2003), also published by Arcadia Publishing.

Many train rides through Michigan City on the South Shore Line, shopping trips to the downtown area, Marquette Mall, and The Lighthouse Place made me curious about the history of Michigan City. This pictorial history is based on available images and it is by no means meant to be comprehensive.

Robert Rosenbaum has an impressive postcard collection which he lent us for *Harbor Country*, and it motivated me to write this book. Rosenbaum put me in touch with Mike Fleming, who sent me his collection of scanned postcards, documents, and other images used in this book. Barbara Stodola's *Michigan City Beach Communities* (Arcadia, 2003) provided valuable information.

The Old Lighthouse Museum has a wonderful collection of photographs of Michigan City's history in its archives. Many thanks go to Jackie Glidden, director of the Michigan City Historical Society, for her patience and her permission to scan these images, and to June Hapke, archivist.

The Michigan City Public Library maintains a user-friendly website that provided much of the background information for this book. The website contains *The Portable La Porte County*, the *Michigan City News Dispatch* online, and some of the oral histories collected from over 100 older residents. The pamphlet file in The Indiana Room in the Michigan City Public Library was another valuable resource. The Michigan City Public Library houses over 6,000 historic photographs produced by The History Project CETA Title VI.

Thanks to Kitty Mross and Judd Chesler for their encouragement and for lending me their books. Good sources for further reading include Gladys Bull Nicewarmer's *Michigan City, Indiana: The Life of a Town*, 1980, and Elizabeth Munger's *Michigan City's First Hundred Years*, 1969. "Pioneer Michigan City," a pamphlet published by the Michigan City Historical Society in 1969, outlines a walking tour and contains the city's history in a nutshell. *A Little Bit of History, Book One*, also published by the society, features anecdotes and scraps of history written by Dude Calvert for the *Old Lighthouse Museum News*. *The Cruise of the Zoo Board: Tenth Anniversary Souvenir Bulletin Booklet of the Washington Zoo Board*, 1938, demonstrates residents' civic engagement.

INTRODUCTION

In 1826, the U.S. Government acquired the title to the land where Michigan City stands through a treaty with the Pottawatomie Indians. In 1828, surveyors determined that the mouth of Trail Creek would be a good location for a city and a commercial harbor. Major Isaac C. Elston of Crawfordsville, Indiana, learned of the plans for both road and harbor, and bought a parcel of land that contained Trail Creek in 1830. Michigan City was platted in 1832. Elston later sold his holdings to the Michigan City Land Company, and Michigan City was incorporated in 1836. Elston's city was bound by Trail Creek, Wabash, Spring, Fifth, and Ninth Streets. Elston, however, never lived in Michigan City.

Trail Creek became part of Indiana Territory and contributed to the young city's growth before the harbor was developed. As Michigan City grew, its lake traffic increased, and lumber and grist mills lined Trail Creek's banks. The city's location near well-traveled Indian trails and the Michigan Road opened northern Indiana to more settlers. The Michigan Road was in use by 1832, and men who worked on it settled near the lakefront. Samuel Miller, the city's earliest settler, built a log cabin and a warehouse. Hundreds of wagons lined the Michigan Road on the way to the harbor.

Pine and hardwoods encouraged a thriving lumber industry. Milling and shipping lumber became a profitable business, and by 1890, Michigan City was one of the largest lumber markets in Indiana. Natural resources included sand (from the Hoosier Slide), which was shipped to many parts of the U.S. and Mexico for glassmaking. Merchants offered services to travelers: food, shelter, and supplies. Visitors to Michigan City responded with awe to the town's geography and houses. A visitor who went by boat from St. Joseph, Michigan, to Chicago in 1836 mentioned he saw between twenty and thirty houses and a dozen stores among the sand hills.

The fledgling city was a small village settled by pioneers from Kentucky, North Carolina, Tennessee, and Virginia who came up the Ohio River. It was hoped that the new city would surpass Chicago in commercial importance and size. In 1832, Michigan City competed with La Porte to become the county seat of La Porte County, but lost due to its low and swampy surroundings and La Porte's more central location.

After the Erie Canal was completed in 1825, settlers from New England, enticed by cheap government land, came to a place of windswept dunes, marshes, and rivers. Wild game, deer, prairie chickens, geese, turkeys, raccoons, fox, and bears were plentiful. Philanthropists such as George Ames, John Barker, and others donated their time, money, and energy to making the city a better place to live by supporting the arts and churches, and establishing a library and a YMCA.

Though Indiana boasts only 40 miles of Lake Michigan shoreline, the lake played a vital role in Michigan City's history. A sand bar blocked the mouth of Trail Creek, and boats anchored offshore. Merchandise was unloaded and brought to shore via barges and "lighters." Congress freed money to dredge Trail Creek's channel in 1867, and in 1870, the Army Corps of Engineers dredged the channel to a depth of 12 feet. In the late 1880s, commerce in Michigan City centered on its harbor. The lighthouse served as the harbor beacon from 1858 to 1904, when a new one was erected on the East Pier. The pier was extended in 1904, and the breakwater was rebuilt in 1911.

Michigan City's economy rose and fell. The coming of the railroads resulted in the demise of the port as smaller towns were connected to cities by rail. But the arrival of the Michigan Central Railroad and its car shops in 1850 attracted laborers from Europe. In 1852, railroad lines included the Michigan Central, the Monon, the Nickel Plate, and the Pere Marquette. The Northern Indiana railroad ran an electric train in 1903, and the South Shore Line, also an electric train, began its service in 1908. In 1917, the Michigan Central repair shops were moved to Niles, Michigan. A chamber of commerce formed to offset this loss and attracted twenty-two new factories.

One of the first assembly line manufacturers, Haskell and Barker was started in 1858, and by 1879, the five-acre plant employed five hundred men. Michigan City's population doubled as the Haskell Barker Plant expanded. The inmates of the Indiana State Prison, built in 1859, worked both inside and outside the prison. Cheap prison labor attracted other industries, and the prison also became a tourist attraction.

During his tenure as mayor, Martin Krueger secured the land between Lake Michigan and Trail Creek and bridged it; before this, there was no access to the lakefront. Krueger served Michigan City as city clerk, mayor, school board member, and state legislator, and developed Washington Park. By 1910, the shipping business had dwindled and the harbor was in disrepair. The shoreline was covered with debris, and the beaches were covered with trash. The Amusement Center in Washington Park had been destroyed by fire, and roads linking Michigan City to other towns were in bad shape.

In the 1920s, the chamber of commerce published *Michigan City, Indiana*. The copy read: "A great town going to be better. We want you to know about it. Thirty eight miles across the lake by water to Chicago and fifty two by land. A prosperous industrial center and summer resort near enough to Chicago to have all of its advantages and far enough away to have none of its disadvantages. Nearness to selling market, raw materials, transportation, schools, library, public transportation, public institutions, harbor facilities, and educational institutions. The resorter at Michigan City is out in the refreshing atmosphere and surroundings of the country and yet within a few minutes ride of all the city's attractions and activities. Michigan City is becoming known as 'The Atlantic City of the West.'" Michigan City had 20,000 inhabitants at the time.

Lakefront attractions included a bathhouse, shooting galleries, a merry-go-round, a roller coaster and the Oasis Ballroom, where the big name bands from Chicago played. Excursionists arrived by boat and train to enjoy the lakefront and the Washington Zoo.

Wealthy Chicagoans began to build summer cottages along the lakeshore, and during the Depression of 1929, some moved to their summer homes permanently. Hard surface thoroughfares such as the Dunes Highway, U.S. 12, and Johnson Road were built in the 1930s, and U.S. 20 connected Michigan City and Gary. By the 1950s, retail was focused along Franklin Street, and the Marquette Mall was planned at the intersection of U.S. Highway 421 and U.S. Highway 20. Today, a large outlet mall is located where the Haskell Barker Car, which became the Pullman Standard Company, had its works.

In 1966, Michigan City was cited by *Look* magazine as an All-American City for the quality of its community life and its citizen action. In the 1960s and 1970s, the city turned its attention to the preservation of the dune land and improving conditions for pleasure boating and sport fishing. Today, Michigan City is a haven for water sports and a resort for Chicagoans and residents of other nearby states.

One
MAJOR ELSTON'S CITY

Michigan City is named for Lake Michigan and the Michigan Road that ended at the mouth of Trail Creek. A historical marker on the southeast corner of Michigan Boulevard and Washington Street commemorates this road, which ran from Madison, Indiana, on the Ohio River, to Lake Michigan, ending at Michigan Boulevard and Wabash Street.

Major Isaac C. Elston, the first postmaster appointed by President Andrew Jackson, thought the end of the Michigan Road would be a good location for a town. When he learned of the plans for a road and a harbor, he bought a parcel of land that contained Trail Creek in 1830. Elston's city was bounded by Wabash and Spring Streets, and Trail Creek and Fifth Avenue, and went as far south as Ninth Street. Elston, however, never lived in Michigan City and died in Crawfordsville, Indiana in 1867. His initial $200 investment paid off handsomely when he sold the 206 lots in the city he created for $21,689 to the Michigan City Land Company.

Elston set aside the town square for a public park and open air market. The town square was later divided into lots that were sold to help finance the purchase of Washington Park. The La Porte Circuit County Court Building is situated on the north end of what used to be the town square. Willys Peck was elected Michigan City's first mayor. Michigan City lost out to La Porte as site for the county seat in 1832. La Porte was favored due to its central location, and Michigan City was considered too low and swampy.

Charles Cleaver described Michigan City in 1833: "The buildings consisted of one small brick tavern, a frame one opposite, a blacksmith shop and a half a dozen houses, built in, on, and above and below the sand. It contained probably fifty inhabitants." A visitor who took a boat trip from St. Joseph, Michigan to Chicago in 1836, mentioned he saw between twenty and thirty houses and a dozen stores among the sand hills. There were ten hotels in Michigan City in 1836. That number grew as tourists arrived to take advantage of the many recreational, social, and cultural opportunities the city had to offer.

In 1834, the basic population of Michigan City was composed of Easterners. The city was an outfitting community and catered to the needs of settlers and travelers.

Joseph C. Orr established a tannery, and Ralph Couden was a tinsmith. The town was home to the Kellogg Brick Kiln, four groceries, three taverns, five shops, two hotels, and a bank.

Michigan City was promoted as a place where tourists could enjoy the dunes, the beaches, and "the thousand and one delights provided by this ideal vacation city of the West," according to a promotional brochure. Many conventions were held at the Spaulding Hotel, and social events took place at the Vreeland Hotel. Downtown restaurants fed hungry tourists.

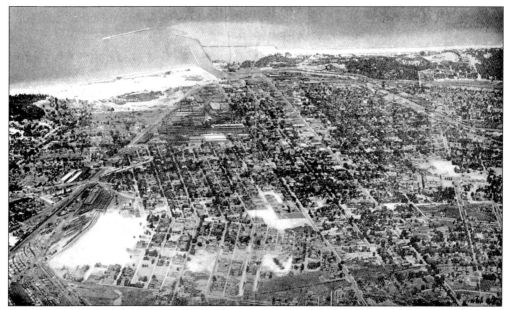

This overview of Michigan City shows the city that was platted by Major Isaac Elston. Trail Creek makes its way to the mouth of the harbor.

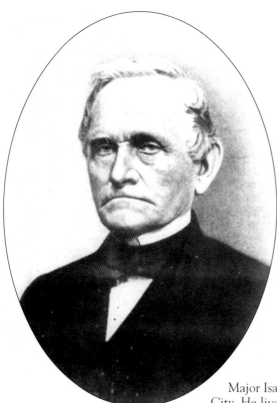

Major Isaac C. Elston was the founder of Michigan City. He lived in Crawfordsville, Indiana.

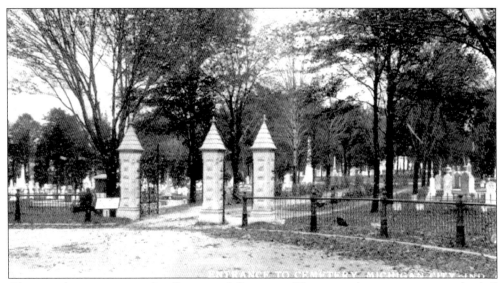

Above is the entrance to the Greenwood Cemetery. The original cemetery was on the hill where the Elston School is now located. Situated outside the city limits, the cemetery doubled as a park and a playground. People took afternoon walks on Sundays and flew kites here. The cemetery was moved to Tilden Ave in 1865. Greenwood Cemetery was named for Jane Greenwood, the first person to be buried there. Abijah Bigelow, a Revolutionary War veteran and a Minuteman, is buried in the original cemetery.

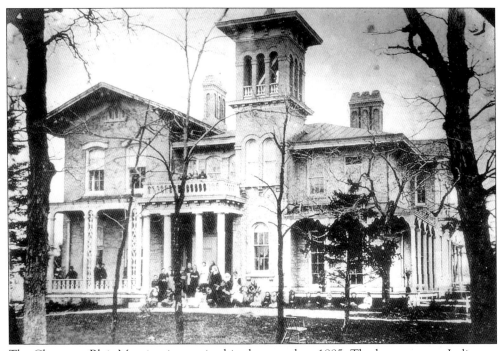

The Chauncey Blair Mansion is seen in this photograph c. 1885. The house was an Italianate yellow-brick mansion Blair built for himself and his bride on the northwest corner of Wabash Avenue and Fourth Street. It later became St. Ambrose Academy, a private school run by the sisters of the Holy Cross.

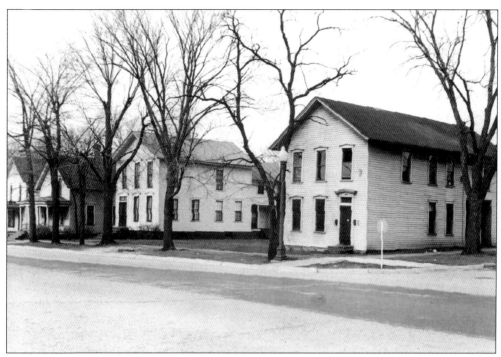

While the "Inner Circle" of wealthy people built their elegant houses along Spring and Washington Streets, these houses on East Williams Street are typical of what the middle class could afford.

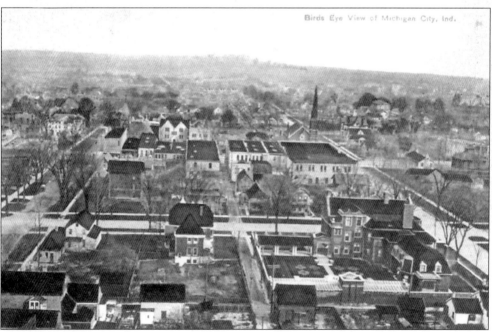

This bird's-eye view of Michigan City allows us to peek into the walled garden of the Barker Mansion, lower right. The mansion has a sunken garden.

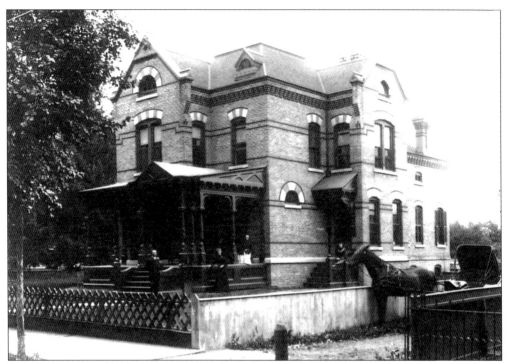

The Orr house on Franklin Street was a brick house built in 1888. Joseph C. Orr established a tannery in Michigan City in 1834.

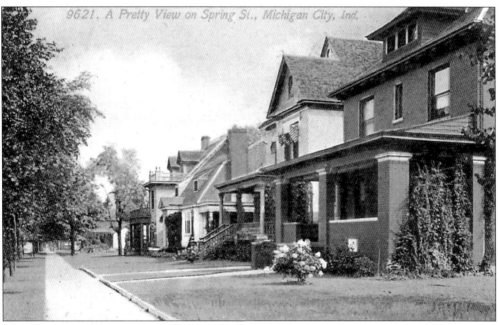

This is a view of Spring Street. Store owners, professionals, and company presidents lived in this neighborhood. The fashionable streets of Michigan City in the nineteenth century were bound by North Washington, Franklin, Pine, and Spring Streets. Factory workers lived near Tenth and Willard Streets.

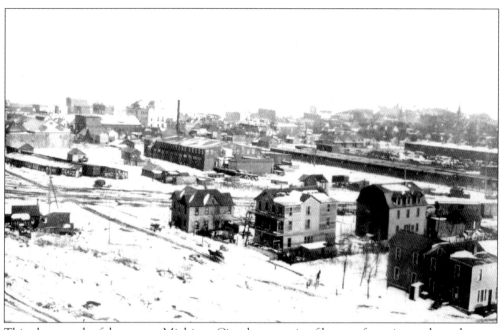

This photograph of downtown Michigan City shows a mix of houses, factories, and warehouses.

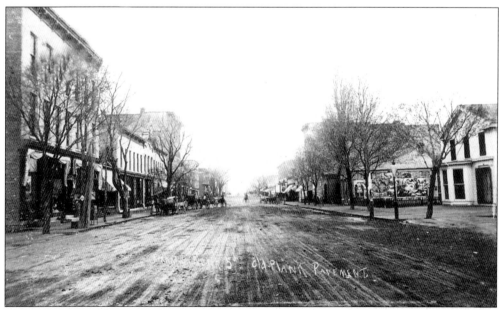

This view of Franklin Street has the old plank pavement that consisted of three-inch white-pine plank laid lengthwise. The plank pavement did not hold up well during rainstorms and was replaced with cedar blocks.

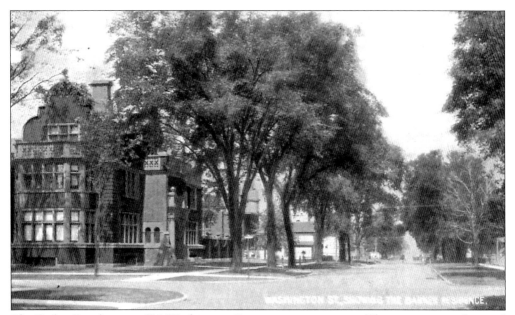

The Barker Residence at 631 Washington Street is now a museum. The mansion was designed by Frederick Perkins and completed in 1905. This three-story house has 38 rooms, 7 fireplaces, 10 bathrooms, a central vacuum system, and a third-floor ballroom. Catherine Barker Hixson donated the mansion to Michigan City as a memorial to her father.

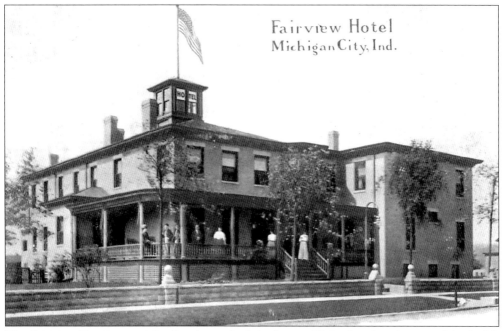

The Fairview Hotel was originally a house built by Lyman Blair. As a hotel, most of the lavish furnishings that had been installed by the Blairs were kept, such as velvet carpets, crimson satin drapes, and lace curtains. From the cupola, guests enjoyed watching boats enter the harbor.

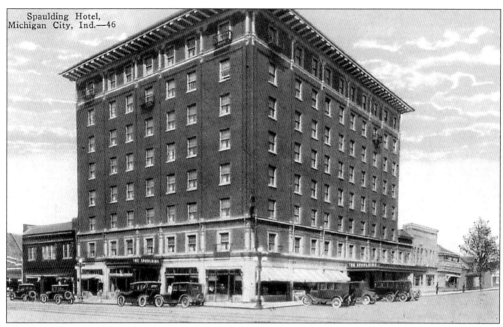

Spaulding Hotel,
Michigan City, Ind.—46

The Spaulding Hotel on Seventh and Franklin Avenues had 150 rooms. Many conventions were held here, and the seven-story hotel was a hub of Michigan City social life and the headquarters of the Miss Indiana Pageant. Though it managed to survive the Depression, during which period there was a casino in the basement, the hotel was closed in 1966 and razed in 1979.

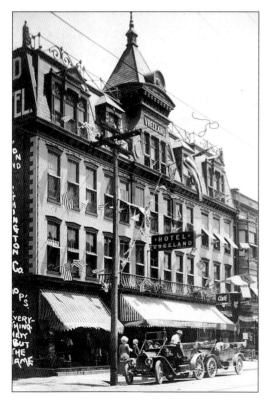

In the 1800s, The Hotel Vreeland was Michigan City's luxury hotel. Members of the fashionable set known as "The 400," held their events here. The Sitters and Stayers Banquet was also held at this hotel. The hotel burned down in 1960.

Tyrell's Hotel and Restaurant was one of the many downtown hotels that catered to tourists who came to Michigan City by train and excursion boat.

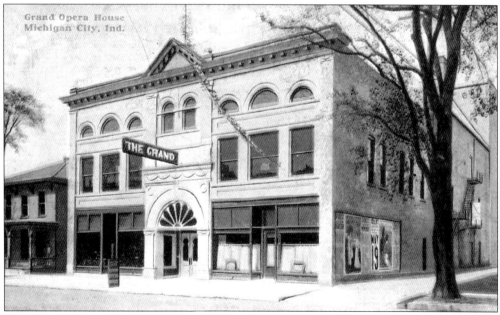

The Grand Opera House opened in 1906 and seated 1,500. Musical comedy and dramatic companies held their dress rehearsals here before they started their season in Chicago. On days of performances, the interurban ran special trains between La Porte and Michigan City. The Opera House burned down in 1921.

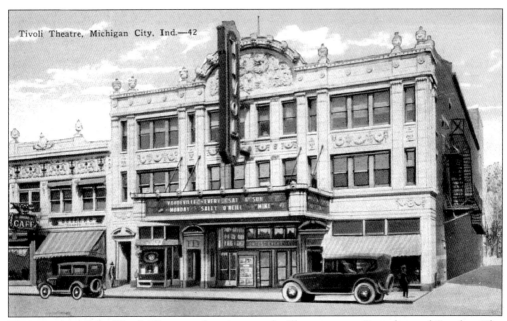

The marquee of the Tivoli Theater advertises vaudeville acts every Saturday and Sunday. The Tivoli Theater opened in 1922. During the Depression, admission was 25 cents.

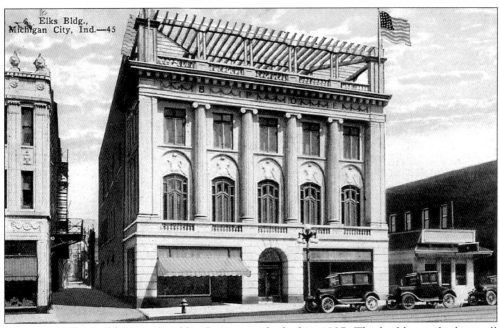

This is the Elks Building on Franklin Street as it looked in 1927. The building, which is still standing, is a Classical design with a pergola on its roof.

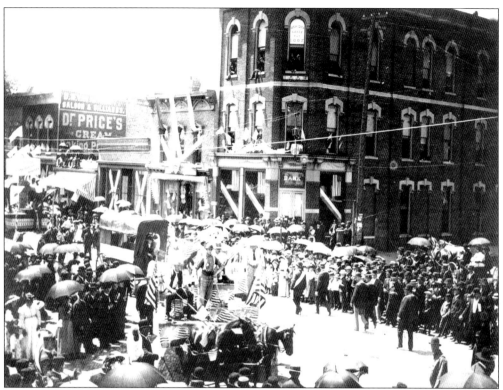

This parade took place on Franklin Street in the late 1890s. The view is looking south on Franklin Street from Michigan Street. Elizabeth Munger, who wrote a history of Michigan City, arrived in 1918, just after Armistice Day, which was celebrated with a parade down Franklin Street.

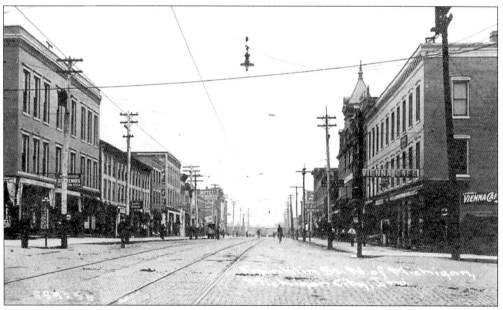

This view of Franklin Street shows the interurban tracks, with the Vienna Café on the right. The plank pavement has been replaced by cedar blocks.

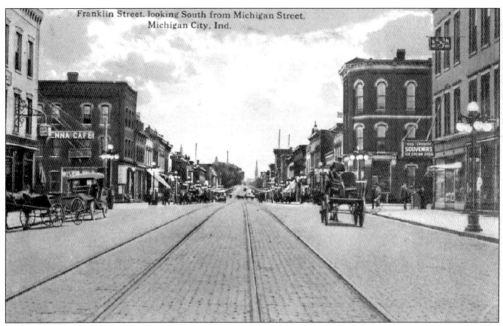

A view of Franklin Street looking south shows the Vienna Café on the left, and the George Leusch Ice Cream and Souvenir store on the right. Horse-drawn carts and cars share the road.

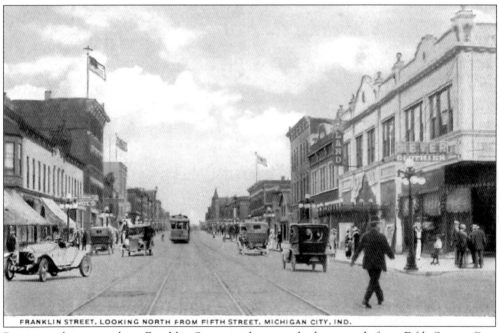

Business is booming along Franklin Street in this view looking north from Fifth Street. Cars and the interurban bring shoppers downtown to buy clothing and shoes. Residents stop to chat on street corners.

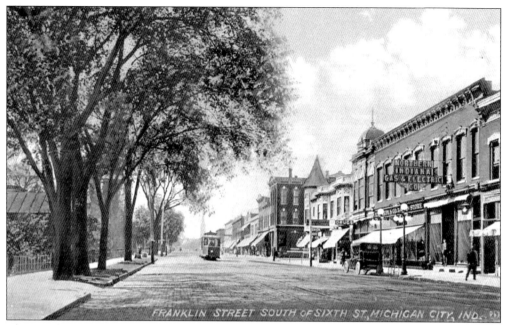

The Northern Indiana Gas and Electric Company is featured here in this postcard of Franklin Street south of Sixth Avenue.

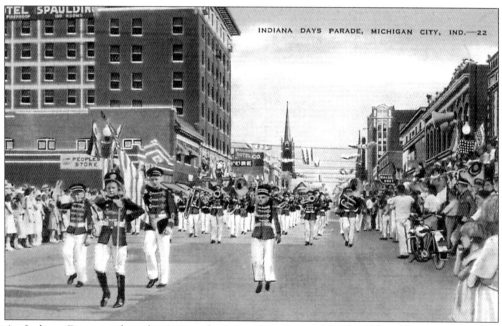

An Indiana Days parade makes its way down Franklin Street. The Spaulding Hotel is on the left. From 1934 to 1938, Michigan City celebrated Indiana Days with a week-long celebration. Indiana Days were discontinued after World War II and revived as the Summer Festival in 1955.

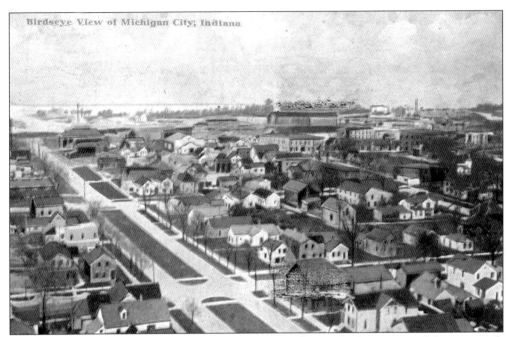

This bird's-eye view of Michigan City shows its growth. At the beginning of the twentieth century, Michigan City was home to the Haskell Barker Company, The Ford and Johnson Company, Lakeside Knitting Mills, Reliance Manufacturing, and Tecumseh Facing Mills, to name just a few of the many manufacturing plants and factories.

These fountains were part of the Franklin Street Mall. Trinity Episcopal Church is in the background. Under the Beachway Development Plan the north end of town was modernized, and most of the nineteenth-century houses and stores were cleared.

22

Two
ON THE WATERFRONT

Michigan City owes its existence to Trail Creek and the Michigan Road. Following a 1834 survey of the creek, Congress appropriated $20,000 to build a harbor. The upper harbor in the channel of Trail Creek was dredged in 1867. In 1870, the Army Corps of Engineers dredged the channel to a depth of twelve feet. Between 1925 and 1953, Congress could not justify funding further dredging.

Plentiful wood in the area led to many lumber yards and furniture factories. Companies such as the Michigan City Sash and Door Company took advantage of Trail Creek's location. At the close of the century, the lumber business was diverted to Chicago, but other products made their way into the harbor. The Michigan Salt Association, one of the largest companies in Indiana, built a warehouse on Second Street near the Harbor. Salt was carried in from Manistee to Michigan City and then distributed throughout Indiana and Illinois.

Michigan City lost out to Chicago in its bid to become Lake Michigan's leading harbor. Following the Panic of 1837, Chicago became the main port on southern Lake Michigan, and Michigan City failed to become the "Metropolis of the West." A proposal to build a railroad running alongside the Michigan Trail was scrapped. Martin Kreuger, Michigan City's mayor from 1889–1927, succeeded in bridging the lakefront to the city. The second Franklin Street Bridge, the first lift bridge, was constructed about 1906.

Uriah Culbert was a state senator and financier who spent time in the California oil fields and in the steamboat and lumber industries in Muskegon. Culbert was a strong advocate of lake shipping, and he built the breakwater and cribs in the outer harbor and the docks and piers in the inner harbor. The extension of the East Pier was completed in 1904, and the breakwater was rebuilt in 1911.

By the 1920s, Michigan City's era as a major lumber port was over. The lumber industry had been diverted to Chicago at the turn of the century. When the railroad came, the warehouses at the mouth of Trail Creek disappeared. The harbor was neglected and the government could not justify funding its upkeep; it deteriorated to the point where it was hardly usable. The Michigan City Port Authority was formed in 1960 and announced plans for a basin, piers, and slips for 200 boats, signaling a revival in recreational and pleasure boating and fishing. Michigan City turned to the preservation of the dune land and development of recreational facilities. Heisman Harbor, a yacht basin with a 30-acre marina and room for 600 boats was developed in 1965.

Old rivalries are not soon forgotten. According to Dude Calvert (Mr. Michigan City):

Chicago was misplaced in the first place . . . the environs of our beloved Trail Creek were the most advantageous, natural and ideal location for a harbor. . . . Michigan City was the Midwest metropolis and should have remained so . . . going back 136 years, our harbor had all the trade and a concerted effort was made by an unscrupulous monopoly to build up the port of that mosquito-laden village across the lake, Chicago, whose only monopoly up to that time had been an overabundance of stinking wild onions.

Near the present Trail Creek Bridge, Father Marquette, a French missionary, preached to a group of Pottawatomie Indians in 1674. Trail Creek contributed to the area's growth, providing a harbor as well as water power to run lumber and grist mills.

This is Upper Trail Creek. The Battle of Trail Creek was the only battle fought in the area during the Revolutionary War. The historical marker in Memorial Park reads "Battle of Trail Creek, December 5, 1780." In the aftermath of George Rogers Clark's conquest, a party of Americans and French from Cahokia, led by Captain Baptiste Hamelin and Tom Brady, after raiding Ft. St. Joseph, were defeated and captured in this area by fur trader Etienne Champion, and Pottawatomie allied of the British."

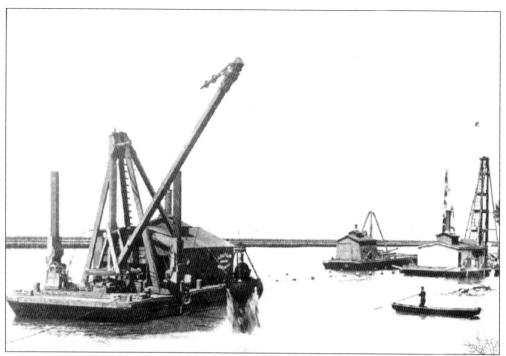

The harbor needed dredging because a large sand dune blocked the mouth of Trail Creek, forcing boats to anchor offshore. Merchandise was unloaded and brought to shore via barges and "lighters." In 1870, The Army Corps of Engineers dredged the channel leading to the harbor to a depth of 12 feet.

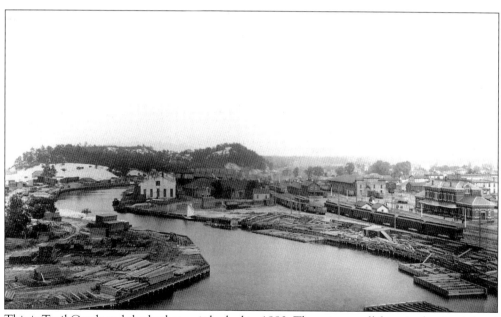

This is Trail Creek and the harbor as it looked in 1880. There is a small ferry in the river's bend on the left. The Michigan City depot is on the right. The photograph was probably taken from the top of the Hoosier Slide, and Yankee Slide is in the background.

These boaters on board the Marquette, and others in canoes, enjoy their ride on Trail Creek.

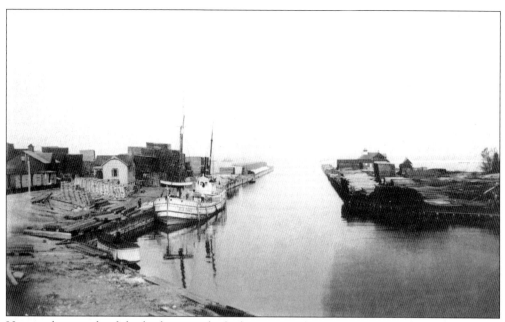

Here is the mouth of the harbor as it looked in 1890. The area where Washington Park now stands was occupied by lumber companies in the late 1880s. Men referred to as "dock wallopers" unloaded lumber.

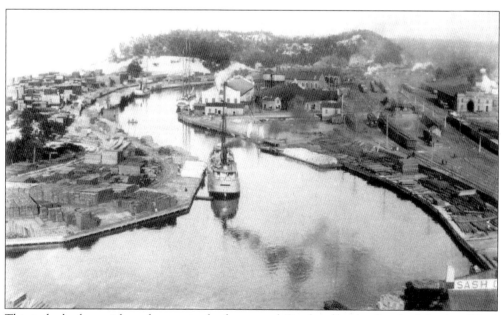

This is the harbor, with a schooner in the foreground. Stacks of lumber line both banks of Trail Creek. Two thousand schooners plied the Great Lakes in the late 1800s. As many as 25 schooners moored in Michigan City on weekends. Cargoes were unloaded while their crews headed for the many saloons in town.

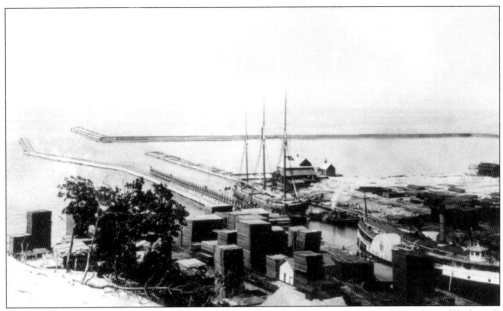

A schooner and a side-wheeler are in the harbor. The harbor was a bustling place filled with sailing vessels, fishing boats, and barges moving lumber and grain.

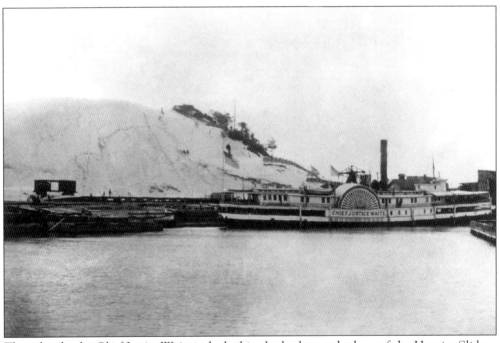

The side-wheeler *Chief Justice Waite* is docked in the harbor at the base of the Hoosier Slide.

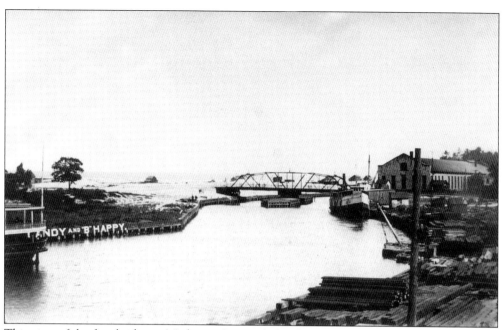

This view of the first bridge in Michigan City includes the Michigan Central Roundhouse and its repair shops.

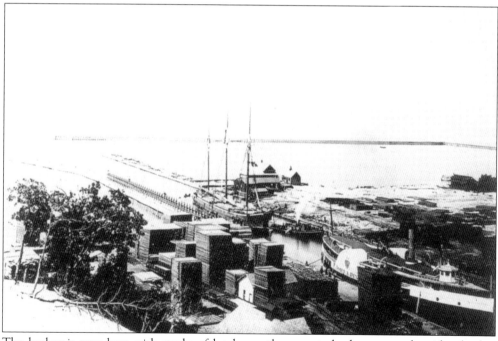

The harbor is seen here with stacks of lumber, a three-masted schooner, and a side-wheeler. Lumber and grist mills were built along Trail Creek, and lumber was shipped out from the harbor.

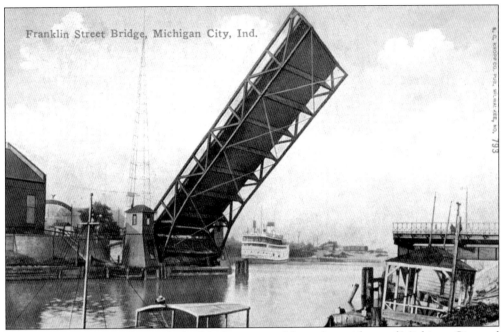

The Franklin Street Bridge made the lakefront accessible to the residents of Michigan City and the many tourists who visited. Mayor Martin Krueger secured the land between Lake Michigan and Trail Creek to build the bridge. Building the Franklin Street Bridge led to the development of the lakefront and Washington Park.

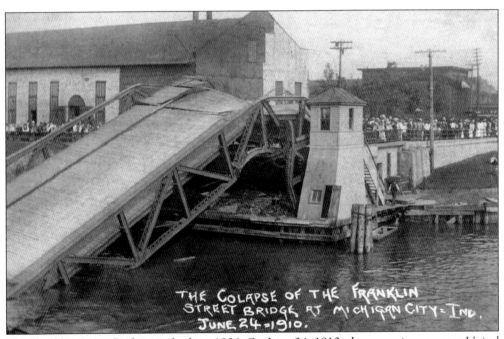

The Franklin Street Bridge was built in 1906. On June 24, 1910, the excursion steamer *United States* backed into the bridge and collapsed it. The tug towing the steamer sank to its smokestack. A new bridge was built in 1911.

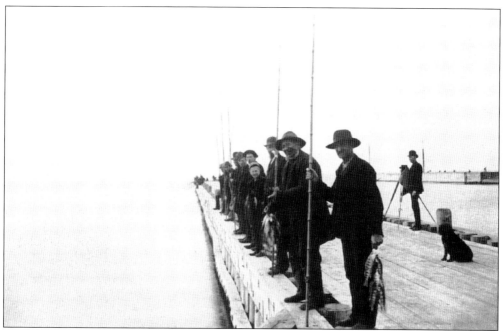

Fishermen on the pier show off a good day's catch. A photographer stands behind them, a reminder that the harbor, pier, and lighthouse served as inspiration to photographers and artists.

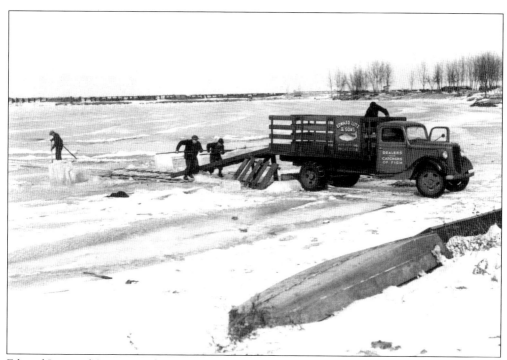

Edward Lutz and Sons ran a thriving fishing business. Here they are harvesting ice from the basin.

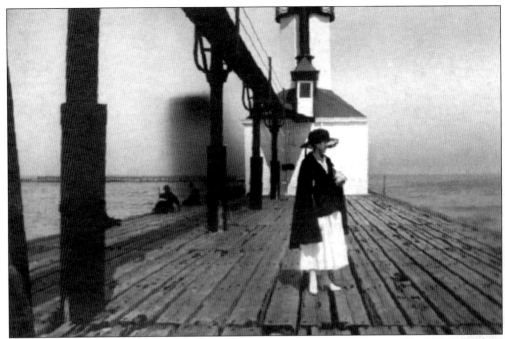

A fashionably dressed woman looks out from the old wood pier in 1920. The lighthouse was built at the harbor's entrance in 1904 and is Michigan City's symbol. It is Indiana's only operating lighthouse and is maintained by the Coast Guard.

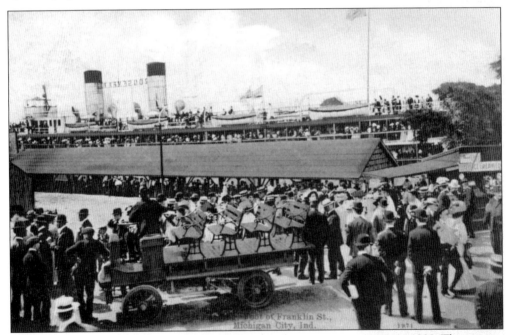

Here is the U.S. *Roosevelt* and an excursion wagon ready to transport visitors in 1908. The steamer *United States* also brought visitors to Michigan City. America, another steamer, ran two daily excursions to Chicago. It was operated by the Chicago and Michigan City Line during daylight hours. A businessman could work in Chicago and be back in Michigan City by dinnertime.

Whether or not these youngsters got to ride in a real boat, they at least made it to Park Studio, where this picture postcard was taken.

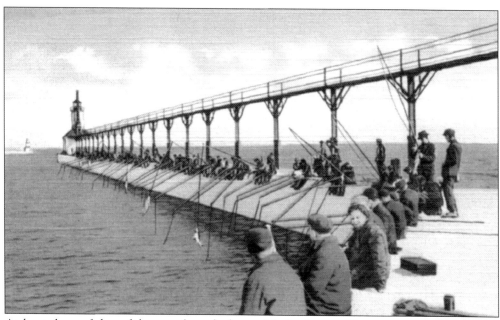

At least three of these fishermen brought home fish for dinner. The pier attracted both local fishermen and weekend visitors.

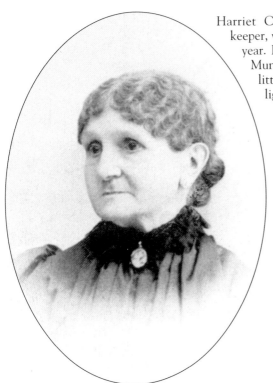

Harriet Colfax, Michigan City's first lighthouse keeper, was appointed in 1861 and was paid $350 a year. In her history of Michigan City, Elizabeth Munger described Miss Colfax as a "dramatic little figure of a woman who operated the lighthouse for 43 years."

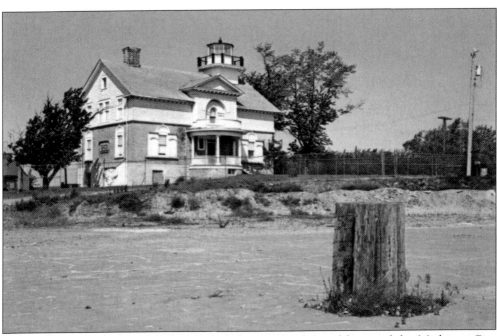

The Old Lighthouse, is now The Old Lighthouse Museum and home of the Michigan City Historical Society. The first lighthouse was built in 1837. The Old Lighthouse was built in 1858 at bend of the harbor. The museum is the oldest structure still standing in Michigan City and is on the National Register of Historic Places.

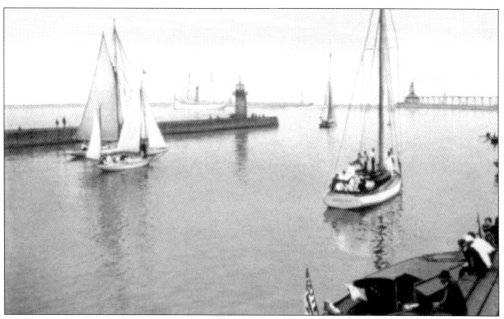

This harbor scene shows the fog horn and the lighthouse. This lighthouse served as the harbor beacon from 1858 to 1904, until the new structure was erected on the East Pier.

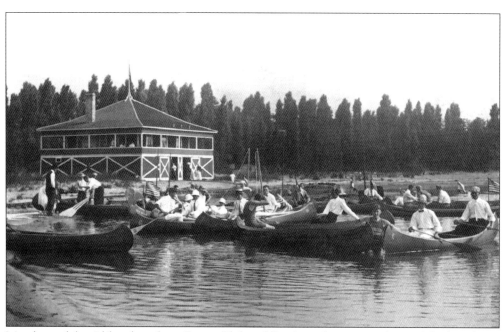

Members of the Ahkasakawehaw Canoe Club paddle along the eastern shore of the boat basin in 1910. The basin was formed by the east pier, built in 1884.

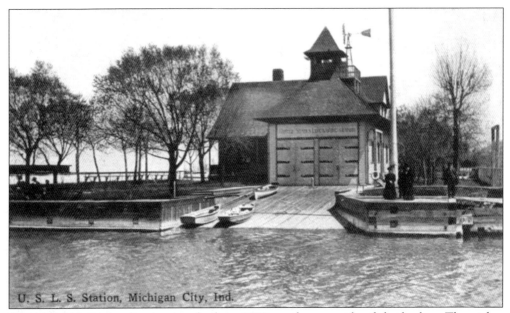

U. S. L. S. Station, Michigan City, Ind.

The U.S. Life Saving Station was built in 1882 on the east side of the harbor. The eight-man lifesaving crew was on call and responded to alarms. They also kept track of harbor use and recorded weather conditions. The Life Saving Service became part of the U.S. Coast Guard in 1915.

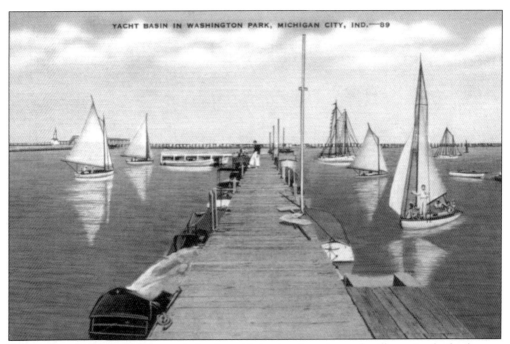

YACHT BASIN IN WASHINGTON PARK, MICHIGAN CITY, IND.—89

This is a tranquil scene of the yacht basin, with its wooden pier and sailboats in the harbor.

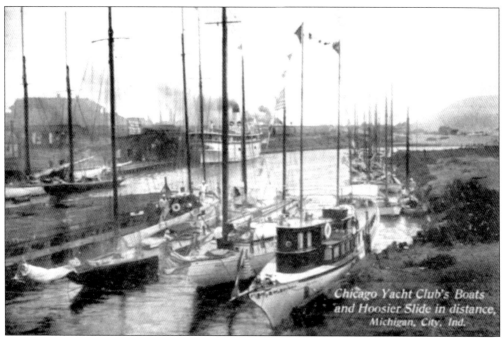

The Chicago Yacht Club's boats are in the harbor, and the Hoosier Slide is in the distance. Michigan City has been the finish line for yachts sailing in Chicago's Columbia Club Yacht Race since 1890. The event is held on the third Saturday in June and is the oldest fresh-water race in the world.

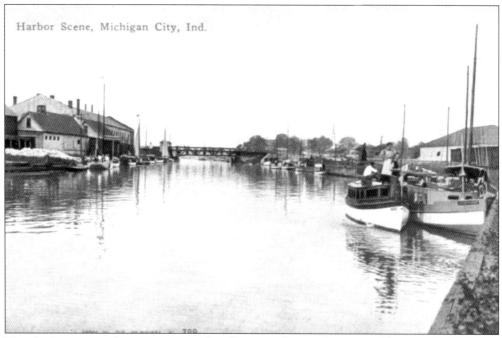

This harbor scene shows recreational sailboats and motorboats. Michigan City turned its attention to preserving its dune land and encouraging recreational boating and fishing.

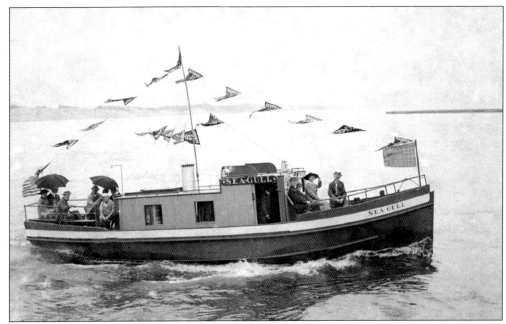

With pennants flapping in the breeze, the Seagull sets out for a ride in the harbor in 1915.

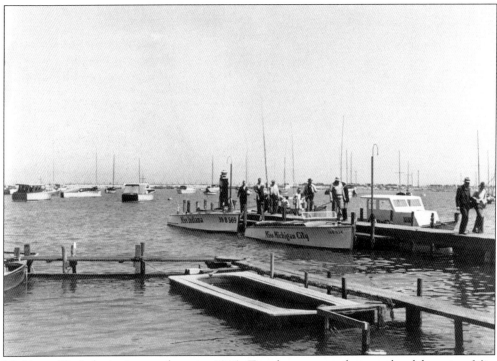

Michigan City's basin is seen here in 1946. Two boats pay tribute to local beauties: *Miss Michigan City* and *Miss Indiana*.

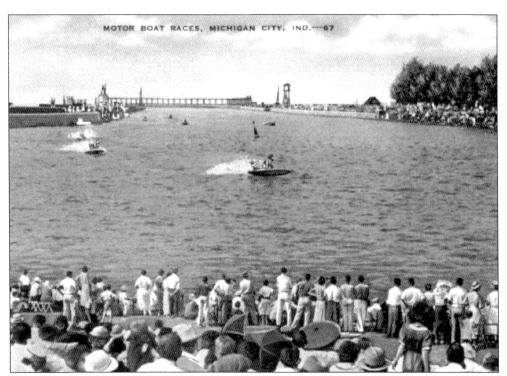

Motor boat races take place in the harbor to the crowd's delight. Motor boat racing was one of the many events featured in the annual Indiana Days Festival.

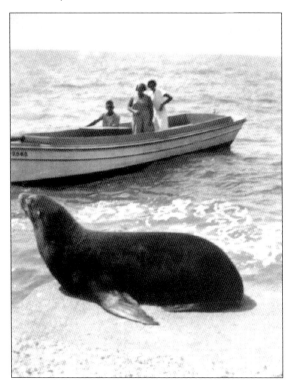

This seal traveled to Michigan City's outer breakwater. A spectator took the photograph from the Heisman Surf Boat.

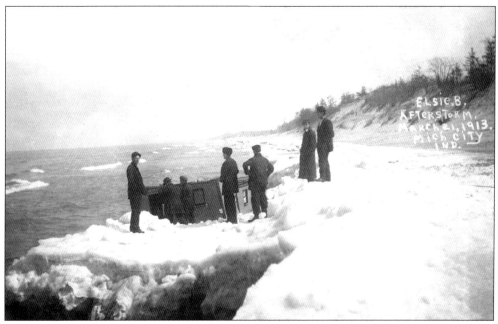

The tug *Elsie* is stuck in the ice following a storm in March of 1913. High water and storms in 1929 and 1930 caused extensive damage to the beaches and southern shores of Lake Michigan.

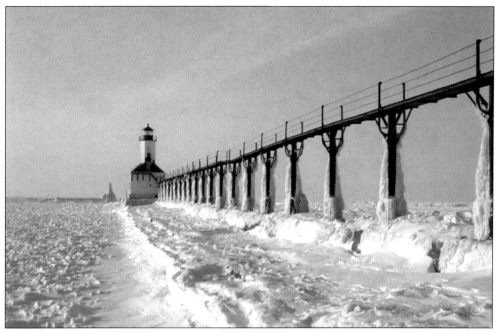

The pier and the lighthouse are photographed in a winter scene. The lighthouse is the symbol of Michigan City and the subject of many photographs and paintings.

Three
FROM TRAILS TO RAILS

Ten pioneer railroad lines ran through Michigan City: the New Albany & Salem, the Michigan Central, the Michigan Southern, the Cincinnati-Peru-Chicago, the Pittsburgh-Ft. Wayne-Chicago, the Baltimore & Ohio, the Wabash, the L.E.&W., the Monon, the P.M., and the Pennsylvania Railroad. Between 1850 and 1860, a stage line ran between La Porte and Valparaiso, and from 1865 to 1871 there was a 16-passenger mail and bus line that ran from Michigan City to La Porte.

An early traveler to Michigan City, Harriet Martineau, complained about the roughness of her stagecoach trip, claiming that passengers had to carry eggs in each hand to keep them from breaking. But for Martineau, travel by railroad was no improvement. She wrote, "The roadbeds were poor, the engine boilers leaked, the trains would more than likely arrive hours late." On one of her short railroad trips, sparks from the locomotive burned no fewer than thirteen holes in her gown.

The Michigan Central Railroad established its car shops in 1850 and attracted laborers from Germany, Sweden, Norway, and Poland. The railroads brought new industries such as the manufacture of freight cars. The car factory played an important part in Michigan City's economic history. Haskell and Barker, one of the first assembly line manufacturers, was started in Michigan City in 1858. On the eve of the Civil War, Michigan City was one of the eleven leading industrial towns in Indiana and was on its way to becoming the transportation hub of the Southern Great Lakes Region.

Tracks for streetcars were laid in the early 1880s. The streetcars were pulled by mules at first, but were electrified in 1907. The trolleys ran from Michigan Boulevard to Carroll Avenue, west to the Indiana State Prison, and south to Coolspring Avenue. The terminal was at Second and Franklin Streets. The route was discontinued in 1932. There were three interurban lines: the Northern Interurban, the South Indiana (The Murdock Line), and the Shore (The Hanna Line). The first South Shore train arrived in Michigan City in 1908 after a two-hour trip from Chicago.

The Dunes Highway was begun in 1920. Motorists could now arrive in Michigan City by car.

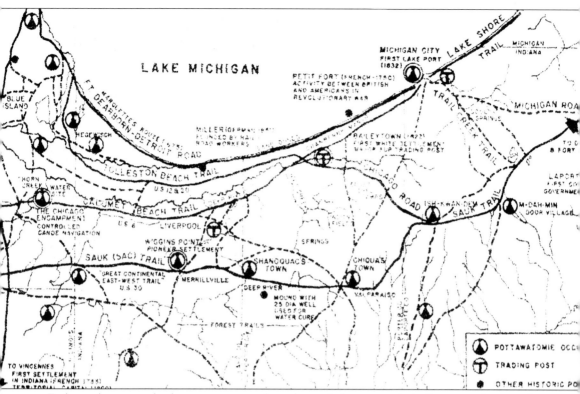

Early settlers came by boat or stagecoach and traveled over roads built to supplement the Michigan Road. The Yellow River Road (U.S. 35) went to Knox by way of La Porte. Michigan City was connected to Lafayette by a ferry across the Kankakee River, and a road went from Michigan City to Door Village. In 1839, another road connected Michigan City to Hammond and the south suburbs of Chicago. These roads were traveled by foot, mule, or ox, until the arrival of the car.

This map on the cover of Michigan City's Centennial Celebration brochure shows why Major Elston bought the parcel of land that eventually became Michigan City, and why it proved to be a good investment. The drawing shows the terminal of the Michigan Road and the plat of Michigan City on Lake Michigan.

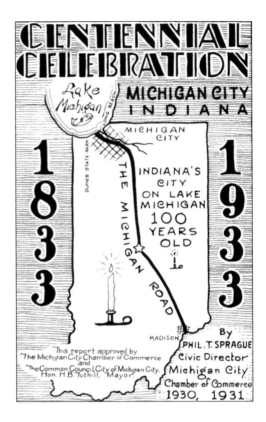

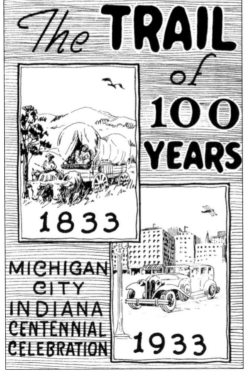

A promotional piece for Michigan City's Centennial Celebration shows the progress in modes of transportation from covered wagons to cars. Early roads were built along existing Indian trails. In 1933, Michigan City celebrated its Centennial with a pageant on the lake front.

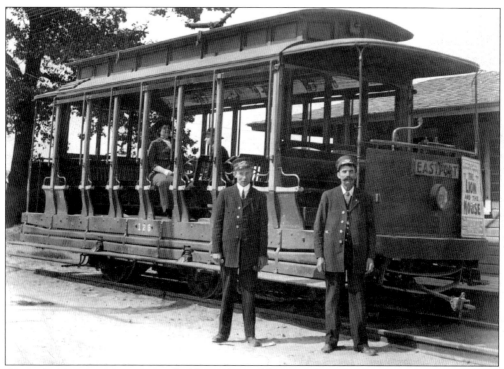

Around 1881, streetcars were pulled by mules and horses. The first electric street cars appeared in 1907, but were retired by the 1930s.

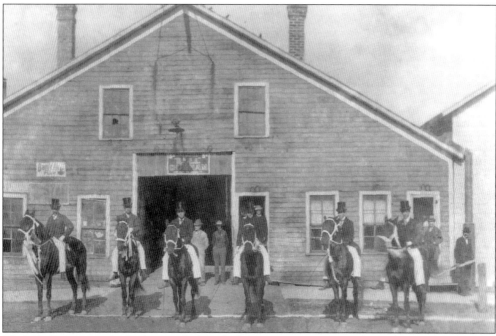

With Earl's barn in the background, the Black Horse Troop gets ready for the parade and rally in honor of President McKinley's visit on October 17, 1899. Earl's Livery also served as the offices for an undertaker.

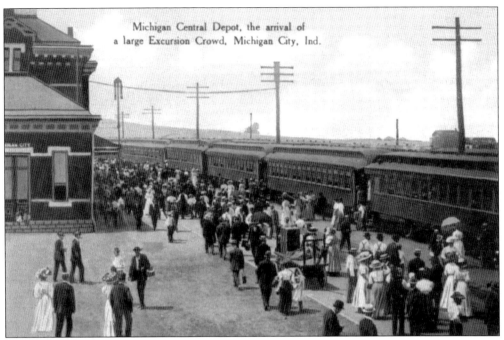

Michigan Central Depot, the arrival of
a large Excursion Crowd, Michigan City, Ind.

Tourists arrived by railroad to Michigan City in droves at the Central Depot. Meeting the passengers at the depot was a big event and a pastime for many. The depot is now a restaurant.

The Michigan Central Railroad depot can be seen here, with the Yankee Slide in the background.

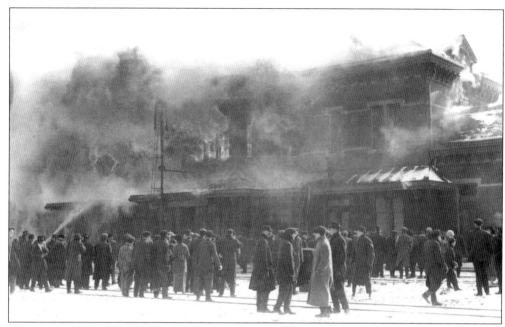

On December 9, 1914, the North Central Depot caught fire and burned to the ground.

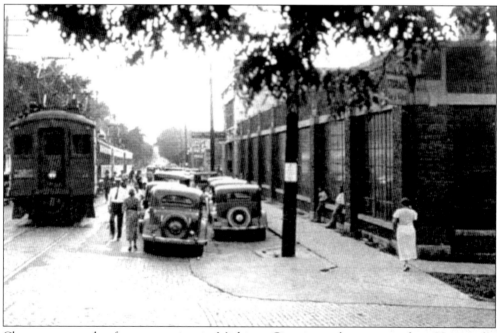

Choose your mode of transportation in Michigan City: interurban, car, or foot. Here is the South Shore Station, *c.* 1918.

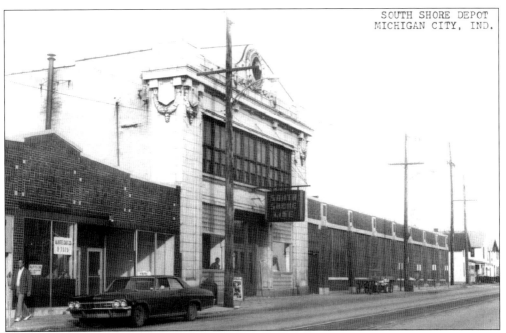

This is the South Shore Line's depot. The South Shore Line runs between South Bend and Chicago by way of Michigan City. Built in 1908, it was one of several electric-powered interurban trains in the Midwest. In 1925, Samuel Insull bought the line and built this station in Michigan City. It is the only remaining electric interurban train running in the U.S.

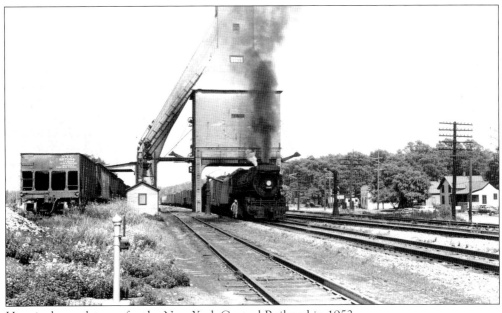

Here is the coal tower for the New York Central Railroad in 1952.

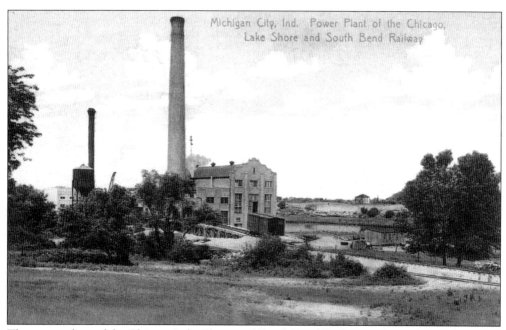

The power plant of the Chicago Lake Shore and South Bend Railway is shown here. The South Shore Line once had dining and parlor cars.

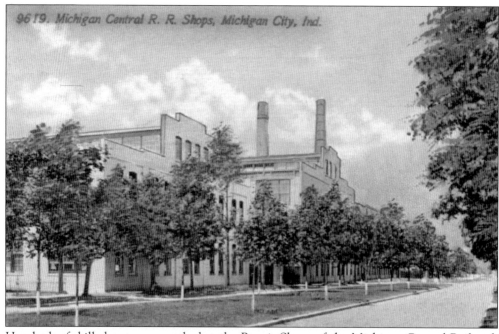

Hundreds of skilled area men worked at the Repair Shops of the Michigan Central Railroad, which serviced the railroad's engines. The Shops and its employees were moved to Niles in 1917. This photograph of the Shops was taken one year before the move.

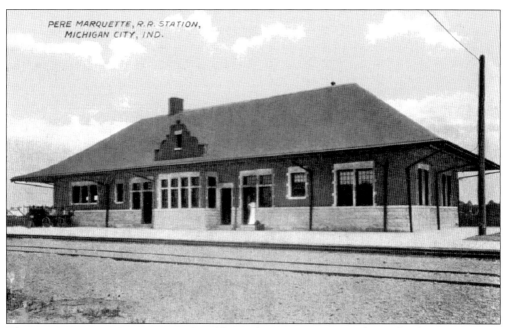

The Pere Marquette Depot was on Franklin and Harrison Streets. This is the depot in 1910.

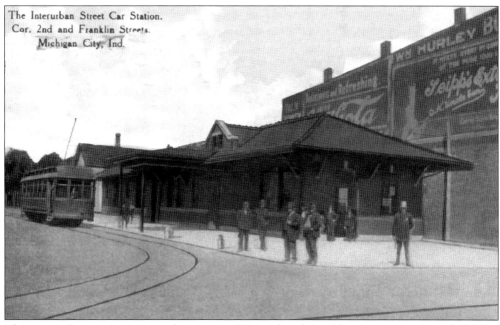

This interurban station was at the corner of Second and Franklin Streets. In the early 1900s, interurbans connected Michigan City to South Bend, Elkhart, and Chicago. In a postcard sent in 1912, the writer commented: "Came over to this place from Chicago by boat. Have been living a strenuous life."

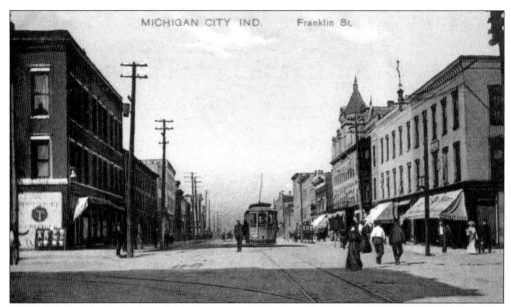

Interurban electric trains, such as this one on Franklin Street, connected cities all over the Midwest. The Depression and the rising popularity of the car drove most of the electric trains out of business. The South Shore Line is the only electric interurban still in business in the U.S.

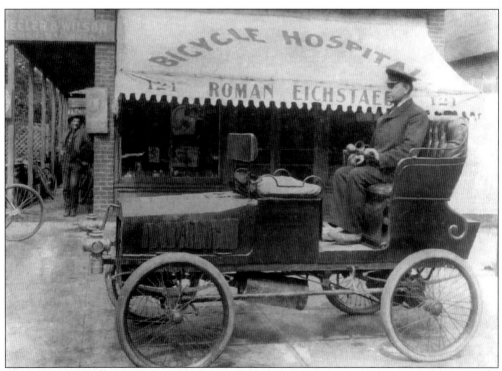

Roman Eichstaed built the first car in Michigan City in 1898. It was a one-cylinder model that could travel up to 20 miles per hour. Local roads, which had been built for horses and wagons, proved a challenge. His machine shop, c. 1885, is pictured here. Eichstaed also manufactured and fixed bicycles.

The crowd is waiting for the arrival of the first airplane to land in Michigan City. Pilots call Michigan City the "City of the Cross" because brightly lit Franklin Street and Michigan Boulevard form the shape of a cross when seen from the air.

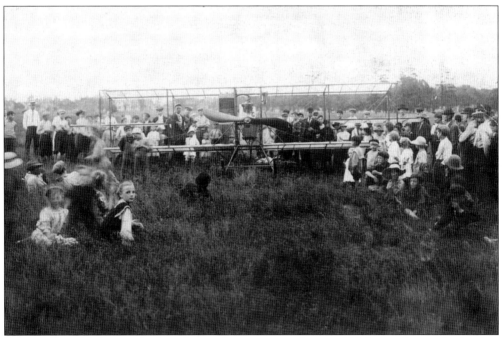

In 1911, Donald Gregory built a plane at his carpenter shop on 803 Spring Street. On his first flight, the plane took off and crashed into a cow. Gregory was unhurt, but he died in a later crash.

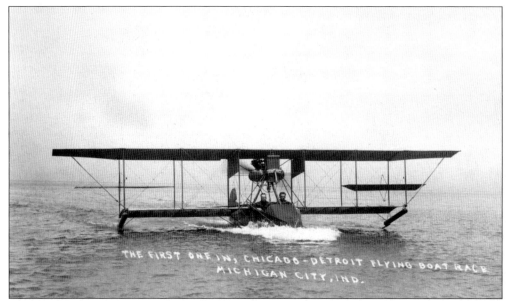

And the winner is . . . "the first one in," the winning seaplane in the Chicago to Detroit Flying Boat Race.

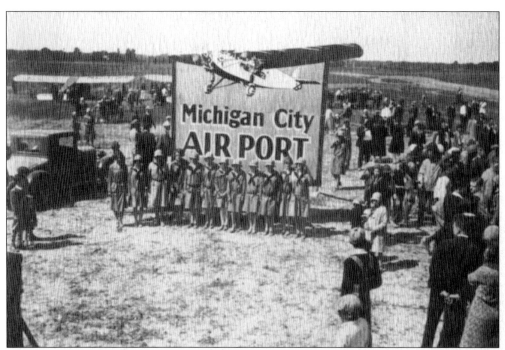

In 1933, stockholders leased the land on which the airport was built to the city for one dollar a year, qualifying it for federal funds. The city then leased the airport back to the stockholders. Amelia Earhart visited Michigan City in 1934.

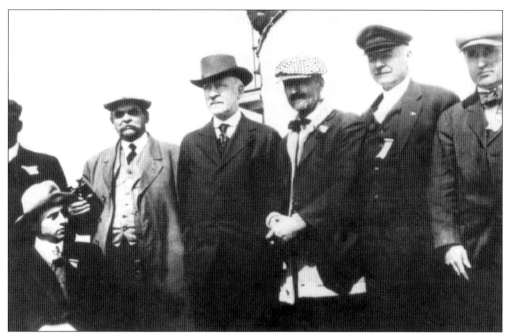

Mayor Martin Krueger (center) attends the dedication of the Michigan City Airport. The airport opened in 1927 at the corner of U.S. 35 and U.S. 20.

Helen Meyer and her dog enjoy a spin in her car.

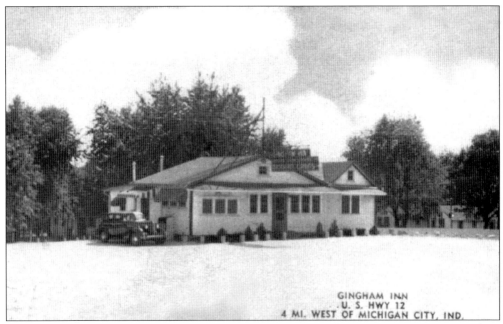

The Gingham Inn advertised clean, steam-heated cabins and innerspring mattresses. Their location, fifty miles east of Chicago and four miles west of Michigan City, catered to motorists.

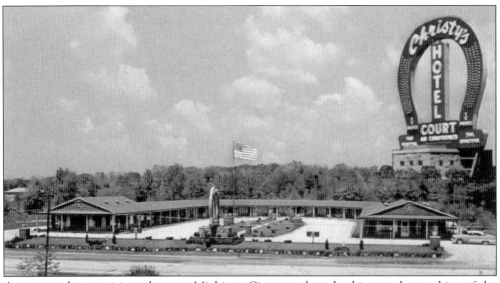

As more and more visitors drove to Michigan City, motels and cabins on the outskirts of the city, such as Christy's Motel, the Skyway and Bryant's, sprang up to accommodate them.

Four

TAKING CARE OF BUSINESS

Since Michigan City was located near several well-used Indian trails and at the mouth of Trail Creek, the city's early businesses catered to the needs of its travelers who were passing through as well as settlers. Merchants provided many goods and services, from flour and lumber mills to blacksmith shops, feed stores, cigar stores, grocery stores, and clothing and millinery shops.

About fifty people lived in Michigan City in 1833. By 1836, the population had swelled to 1,500 and Michigan City had twelve dry goods stores and ten hotels. George and Fisher Ames had a hardware store, and Couden owned a stove, tin, and iron store. Shoes and boots were manufactured in Michigan City, and Addison J. Phillips employed forty cobblers in 1846.

Elizabeth Munger arrived in Michigan City in 1918 and recalls it was a "drummer's town," filled with traveling salesmen. Her family stayed at Powell's Boarding House, a lodging popular with traveling salesmen. Ms. Munger remembered walking through town and hearing Polish, German, and Swedish spoken. Some women wore babushkas, she said, though the younger generations wore American clothes. Ms. Munger's father established the Boy Scouts in Michigan City.

Breweries in town supplied the many saloons frequented by the crews of ships docking in the harbor. Local banks were established. Gas stations were needed as more and more people could afford cars and drove to Michigan City instead of taking the train or steamer. Restaurants, ice cream parlors, and refreshment stands, souvenir stands, and postcard studios catered to the many tourists who arrived in the summer months. Hotels served tourists and conventioneers and hosted social events.

When the Michigan Central Repair Shops moved to Niles, Michigan in 1917, six hundred families moved to their new jobs. To offset this loss, a chamber of commerce was formed; it attracted twenty-two new factories to town.

By the 1950s, retail was focused along Franklin Street and the Marquette Mall was planned. Today, a large outlet mall is located where the Haskell Barker Car plant once stood. Retail continues to draw shoppers to Michigan City.

In the 1960s and 1970s, Michigan City focused on preserving its dune land and attracting pleasure boaters and sport fishermen; it is once again a summer resort.

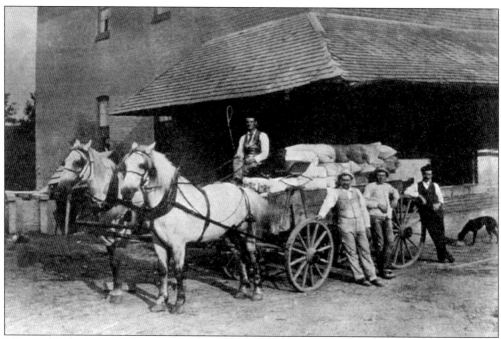

Farmers drove to one of the many mills lining Trail Creek to have their wheat ground into flour. The wagons were pulled by horses or oxen. Scores of ox teams traveled to Michigan City daily.

The Bucket of Blood Saloon was one of more than a hundred saloons in Michigan City. Because of the breweries and the many saloons along Franklin Street, Michigan City was referred to as "a poor man's Milwaukee."

The Christ Rodenbeck Saloon was one of the many taverns in Michigan City. In the 1890s, there were over eighty saloons along Franklin Street. It was joked that Franklin Street needed to be as long as it was so that none of the saloons had to be upstairs.

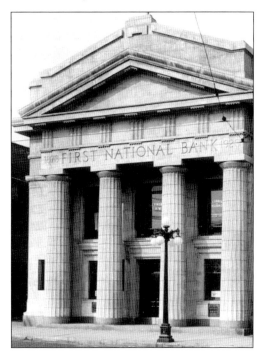

The original pillars of the First National Bank, 1878–1926, are still standing, although the bank was razed. The bank was established in 1873 by Walter Vail of La Porte. Before this bank opened, Michigan City residents banked at a branch of the State Bank of Indiana.

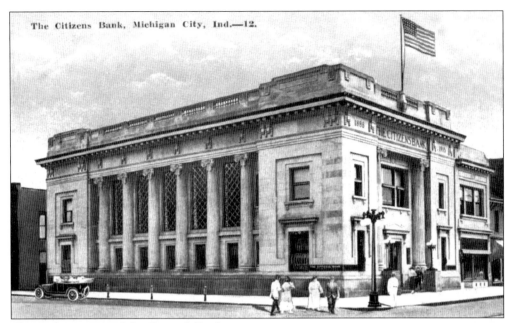

This is the exterior of the Citizen's Bank.

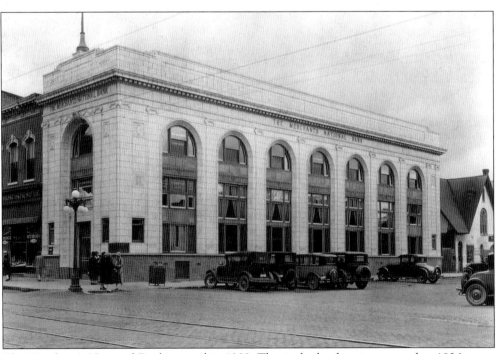

The Merchant's National Bank opened in 1909. This is the bank as it appeared in 1926.

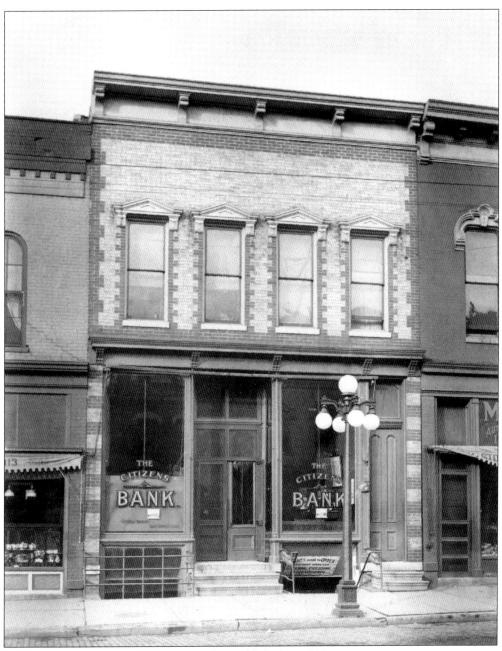

This is the exterior of the Citizen's Bank, established in 1888.

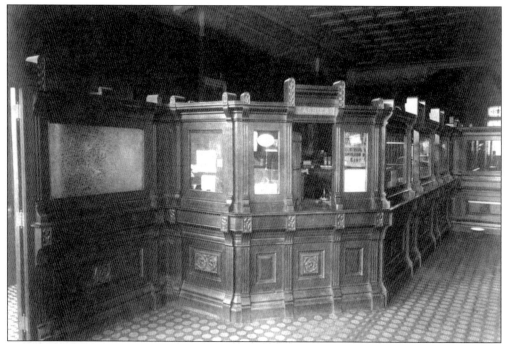

Pictured here is the ornate wood lobby of the Citizen's Bank.

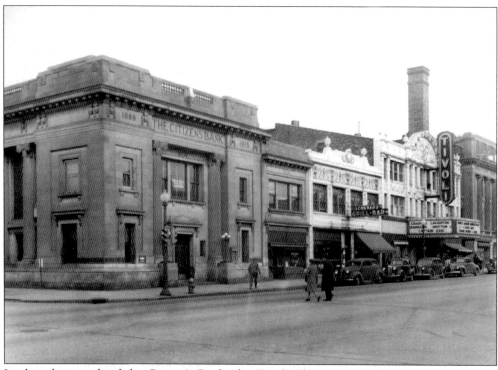

In this photograph of the Citizen's Bank, the Tivoli Theater is to the right, and the Elks Building stands beyond the theater.

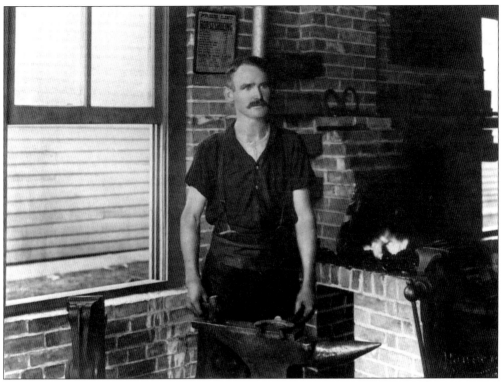

Henry Bennett is shown here in his blacksmith shop on East Michigan Boulevard. Bennett was also a city councilman.

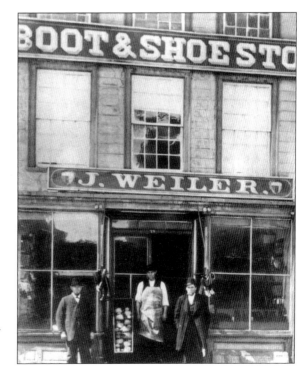

Weiler's Boots and Shoes was one of many shoe stores in Michigan City. Boots and shoes were manufactured and sold in town, and a resident who moved into a boarding house with her family as a child recalls that many traveling shoe salesmen stayed there.

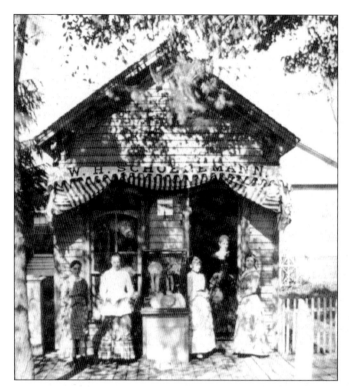

The W.H. Shoenemann Millinery Shop on Franklin Street is typical of the many small, home-owned downtown businesses that thrived in Michigan City before department stores opened. Merchants prided themselves on providing personal attention to their clients. This photograph was taken in 1890.

The Heitschmidt & Fladiger Feed Store was established in 1888. This picture was taken c. 1920.

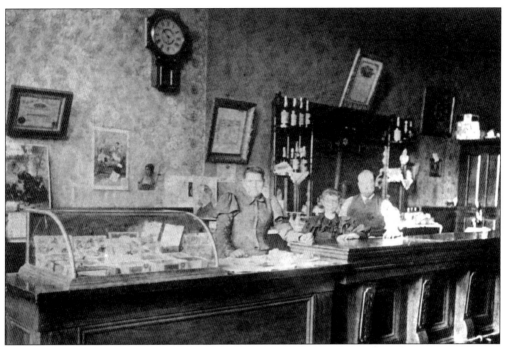

The Mier Store sold cigars in a city where cigar making became a small industry.

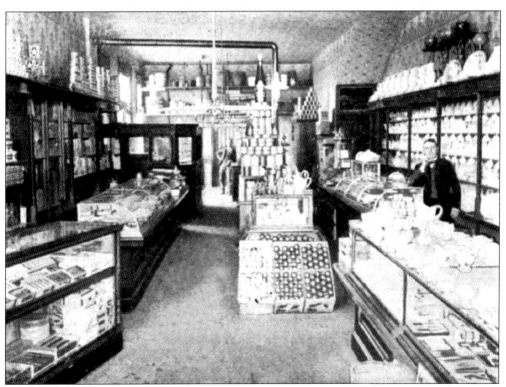

The William A. Zarandt Store was a large double shop at 302–304 West Eighth Street. It carried staples, fancy groceries, and a line of queensware.

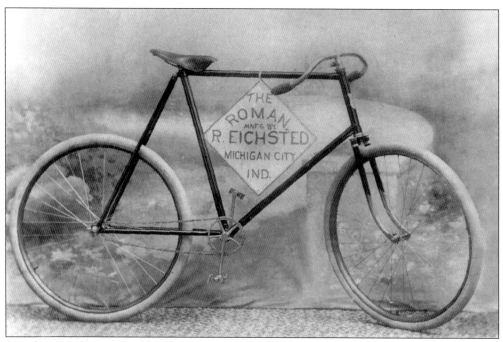

Bicycles were a popular mode of transportation; this is the first bicycle built in Michigan City.

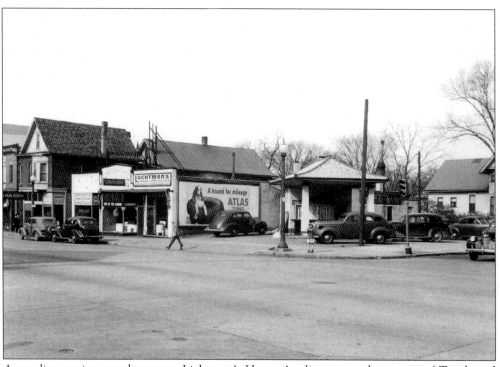

A gasoline station stands next to Lichtman's Home Appliances on the corner of Tenth and Franklin Streets.

Maxine Bragg was crowned Miss Indiana in 1935. The Miss Indiana Pageant was held in Michigan City and took place during Indiana Days.

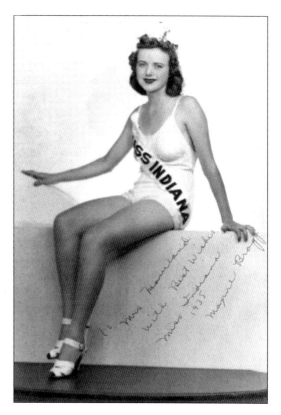

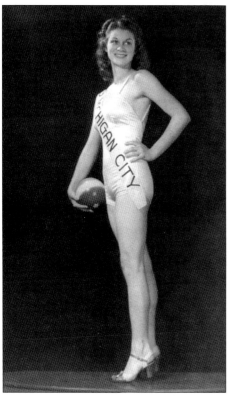

Miss Bennett, crowned Miss Michigan City, poses with a beach ball.

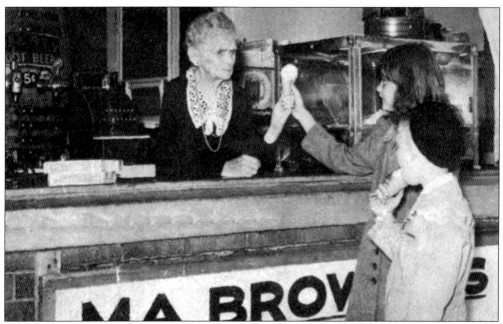

During its many years of operation, Ma Brown's Ice Cream Stand was located in various places near the Franklin Street Bridge. She opened the refreshment stand in 1891 and was famous for her ice cream cones. Ma Brown was still selling her ice cream when Michigan City celebrated the golden anniversary of the Columbia Yacht Race with a Gay Nineties celebration in 1941.

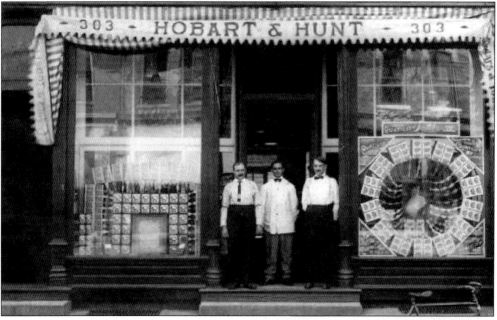

This is Hobart and Hunt, Makers of Cigars and Tobacconists, one of many cigar manufacturers scattered all over town. In 1870, Kumler and Melcher contracted twenty-five men and paid them 50 cents a day to roll cigars by hand. The wrappers came from Sumatra, Cuba, and the Phillipines. The filler for the cigar was domestic tobacco grown in Kentucky and shipped out of Chicago. The cigars were sold locally and delivered to saloons, taverns, hotels, and cigar stores.

Five

A CITY ON THE LAKE

In the 1830s, Michigan City was a grain market. By mid-century, other industries took root, including lumbering, pork packing, flour milling, whiskey distilling, and shipping fish, and cooperage shops provided barrels to Michigan City and Chicago.

Early businesses also included tanneries, brick manufacturers, boot factories, and other industries associated with shipping. Hundreds of wagons lined the Michigan Road on their way to the harbor, and Michigan City became the grain shipping center for northern Indiana.

Scott's Mill was one of the earliest settlements in the state. James M. Scott finished building his grist mill in 1834; it was one of the first flour mills in the township. Farmers brought grain to the mill from Chicago, Rockford, Joliet, and Galena, Illinois, and from the entire northern half of Indiana. The wheat and flour were transported by oxen.

The Indiana State Prison, built in 1859, attracted factories and woodworking shops. The prison hired out the work of its inmates cheaply, and there was lots of lumber to make wagons, carriages, and chairs. After the Civil War, several industries relocated to Michigan City to take advantage of the cheap prison labor. Haywood and DeWolfe's coopering firm hired prisoners and paid them 45 cents a day. But while the availability of cheap prison labor encouraged the growth of factories, the low wages discouraged family men from competing with prison wages.

Shoes and boots, made in Michigan City, meant traveling shoe salesmen, who stayed in hotels and boarding houses. Addison J. Phillips employed forty cobblers in 1846.

Most of Michigan City's growth was due to the manufacture of train cars. The Haskell and Barker Car Company was one of the first assembly line manufacturers. Established in 1858, Haskell and Barker was producing two railroad cars a day by 1869, and the plant covered over five acres. In 1879, the company employed 500 men who turned out 1,000 cars a year. In 1884, 850 men built 6,000 cars a year, including box cars, refrigerator cars, stock cars, and coal and ore cars. During World War II, the company also made troop cars.

In 1924, a chamber of commerce was established to improve the economy of Michigan City, and 22 new factories opened, including Smith Brothers, Royal Metal, and the Hays Corporation. The chamber worked hard to make Michigan City a convention and tourist center, hoping that the total of 11 conventions garnered in 1922, and the 15 of the following year, would be surpassed in the future. The Spaulding Hotel was built to attract even more conventions and tourists, and the city installed a new sewer system.

Fishing was an important industry well into the 1940s. The eight fisheries in Michigan City brought in about 400 tons of fish. Net reels lined the harbor from Second Street to Sixth Street. Huckleberries grew in the tamarack swamps east and west of Michigan City. The huckleberry marsh southwest of the city was called Huckleberry Hell. The inhabitants of this shantytown made their living picking huckleberries in the summer, and in the winter they earned money cutting lumber for fuel for the railroads. Picking huckleberries also provided a source of income for many married women. During the summer months, berry pickers set out before daylight and walked four or five miles to the marshes, picked the berries, and carried them back to town in ten or twelve quart baskets.

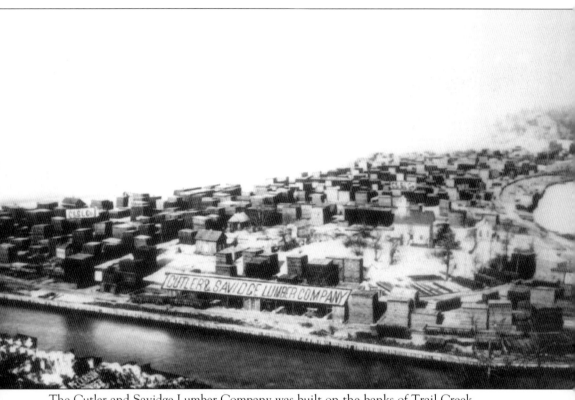

The Cutler and Savidge Lumber Company was built on the banks of Trail Creek.

A glass factory sits atop Hoosier Slide, a 200-foot sand dune that was nine miles in circumference. Sand from this dune was shipped to glassmakers such as the Ball Brothers of Muncie, Indiana, for making fruit jars; the Pittsburgh Plate Glass Company of Kokomo, Indiana; the Hemingrey Glass Company, which made glass insulators for telephone poles; and glassmakers in Mexico. The sand was mined for landfill for Jackson Park in Chicago, railroad right-of-ways, and other sites. When the dune was exhausted, the Northern Indiana Public Service Company bought the site for its generating plant in the late 1920s.

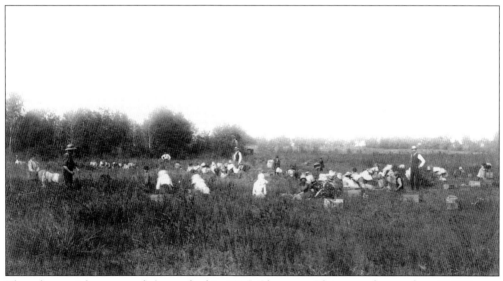

These berry pickers were photographed in 1885. Chauncey Blair owned more than 10,000 acres of land west of Michigan City. Huckleberries grew on his five marshes. There was a natural sulphur spring and a bath house for those who wanted to take the waters. Visitors to the spa arrived by mule-drawn street car.

Electricians ply their trade at the Pullman Plant in 1917.

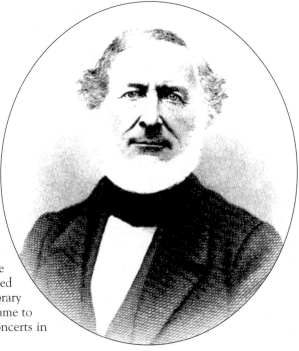

George Ames arrived in Michigan City in 1834, and he and his brother Fisher owned a hardware store. George Ames was a philanthropist who helped to found the Michigan City Public Library and the YMCA. Ames also lent his name to the Ames Band, which played free concerts in Washington Park.

Uriah Culbert came to Michigan City from Muskegon. He was a marine contractor who built the lagoon, the naval pier, the electric fountain, and the foundation for the Ferris Wheel for the Columbian Exposition in Chicago. He served in the state legislature for many years.

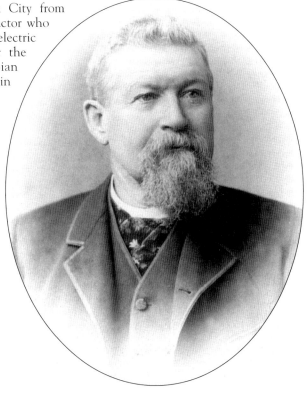

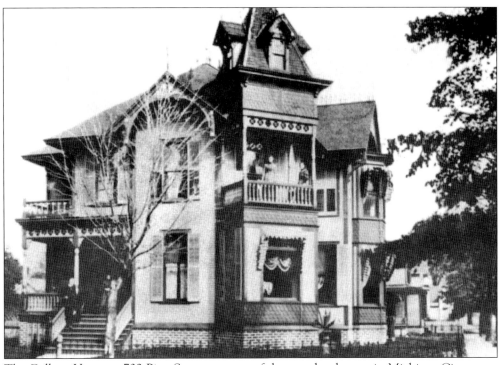

The Culbert House at 732 Pine Street was one of the grandest houses in Michigan City.

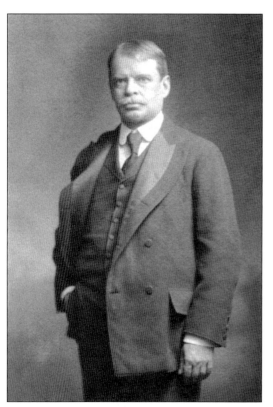

John Barker came to Michigan City from Andover, Massachusetts in the spring of 1836. He was a grain trader and partner in the firm Carter and Barker, and built a grain elevator in the west pier in the harbor.

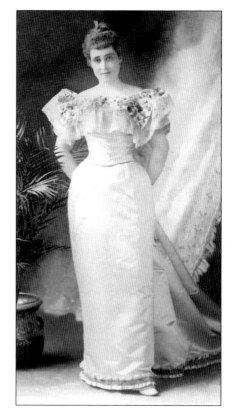

Mrs. John H. Barker was photographed in 1893 wearing one of the glamorous gowns she bought for her wedding. This is the pink dress she was buried in.

This is a photograph of Katherine Fitzgerald Barker, c. 1910. John H. Barker married her following the death of his first wife.

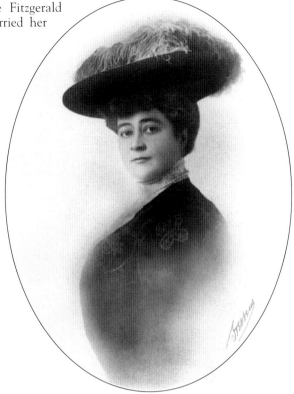

Catherine Barker was 14 when her parents died in an accident on December 10, 1910. The young heiress was photographed at the Calvert Studios. Catherine inherited the Barker Mansion. The house was presented to Purdue University, which used it a study center and to found its North Central Campus. Purdue North Central University later opened its own campus in 1968, near Westville, on US highway 421.

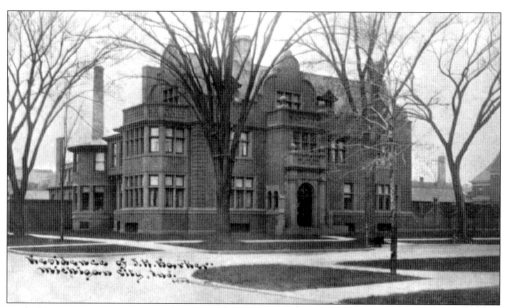

Built by John Barker, the Barker Mansion at 631 Washington Street is now a museum. Designed by Frederick Perkins and completed in 1905, this three-story house has 38 rooms, 7 fireplaces,10 bathrooms, a central vacuum system, and a third floor ballroom. Catherine Barker Hixson donated the mansion to Michigan City as a memorial to her father.

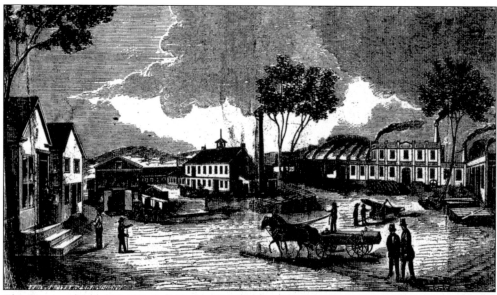

This is a woodcut of The Haskell Barker Car Company, created in 1852, and which eventually became the Pullman Standard Factory. The firm was begun by Haskell, Barker and Aldridge, three men from New York. John Barker was a grain dealer who joined the firm in 1855, when it became the Haskell Barker Car Company. In 1869, John H. Barker, his son, took over the plant and imported workers from Turkey, Syria, and Poland. The company expanded rapidly. By 1908, the factory employed 3,500 men. Pullman-Standard bought the plant in 1922, operating it for almost fifty years until it closed in 1970. A spectacular fire destroyed all but three buildings in 1973. An outlet mall occupies the location today.

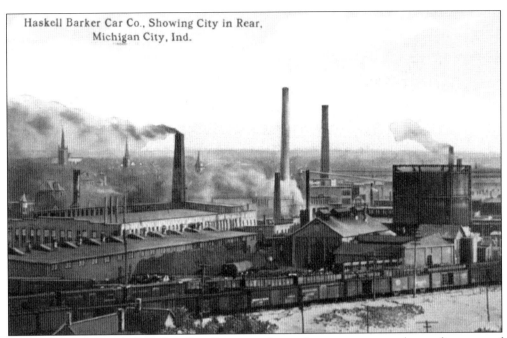

Haskell Barker Car Co., Showing City in Rear,
Michigan City, Ind.

This view of the Haskell Barker Car Company shows the company spread over five acres of Michigan City. This train car factory was vital to Michigan City's economy for many years. Until it closed, the car factory employed more men than any other manufacturing firm in Indiana.

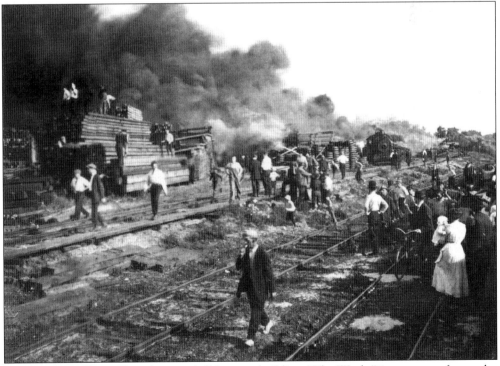

A fire at the Pullman Plant destroyed all but one building. "The Works" is now part of an outlet mall; the Lighthouse Place Outlet Mall broke ground on the site in 1986.

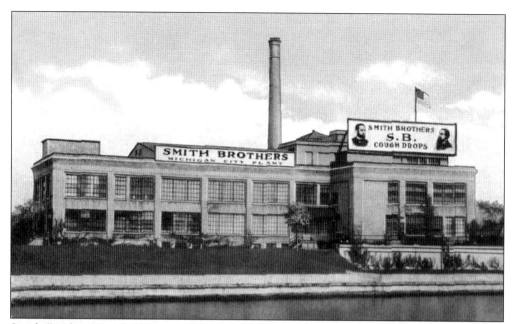

Smith Brothers Cough Drops were first made in Poughkeepsie, New York on James Smith's kitchen stove, and later in his basement. His sons, William and Andrew Smith built a factory in Poughkeepsie, but in order to keep up with demand, a second factory was built in Michigan City. Sixty tons of Smith Brothers Cough Drops could be produced there in one day. The Smith Brothers Michigan City Plant closed in 1959.

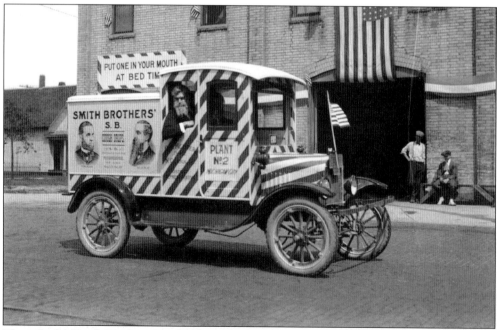

The colorful Smith Brothers Truck advertises Smith Brothers Cough Drops during WWI.

The Ludwig Fisheries on the Ludwig Fishing Dock are pictured here. Nearly a hundred men made their living fishing in the 1890s . Sturgeon was the prize catch, and the fish weighed from one hundred to almost two hundred pounds each.

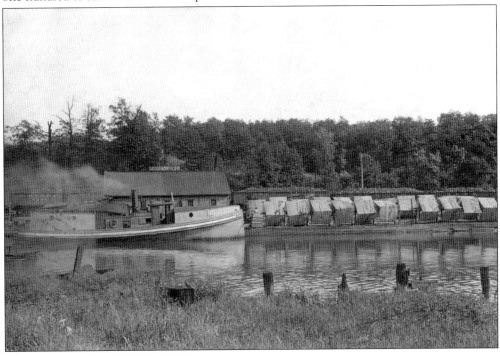

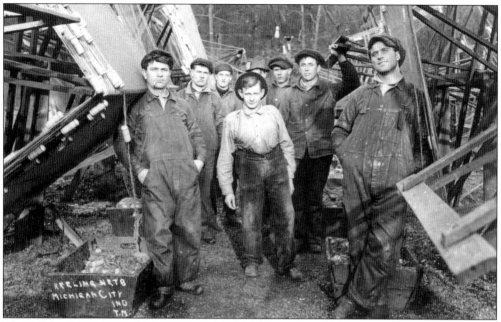

These fishermen are on the jetty near the Hoosier Slide. Some fishermen used gill nets and others used a set of lines with many hooks attached to them.

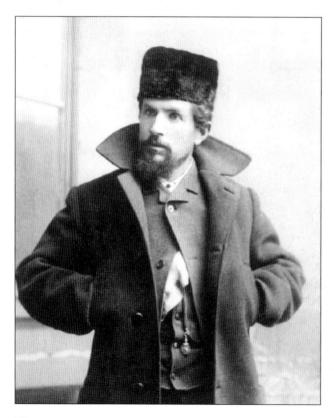

Christopher Roeske built the Roeske Mills. The Roeske Brick and Flour Mill was a very successful firm that produced a high grade brick and Bumble Bee Brand Flour.

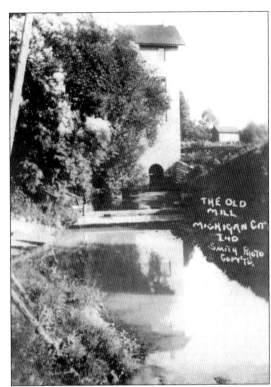

These images show the Roeske Mill—also know as the Old Mill—as it looked in 1910.

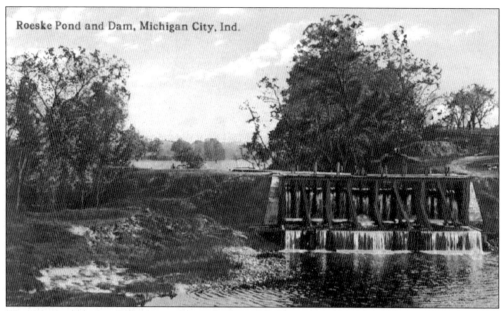

Roeske Pond and Dam, Michigan City, Ind.

The Roeske Pond and Dam was located where Michigan Boulevard crosses Trail Creek. The Roeske Mill was a grist and lumber mill. There were many mills on Trail Creek, and Roeske Mill, built in 1880, also had a brickyard. Many of the streets in La Porte County were paved with Roeske bricks. Roeske Dam was on East Michigan Street, which is now US 20.

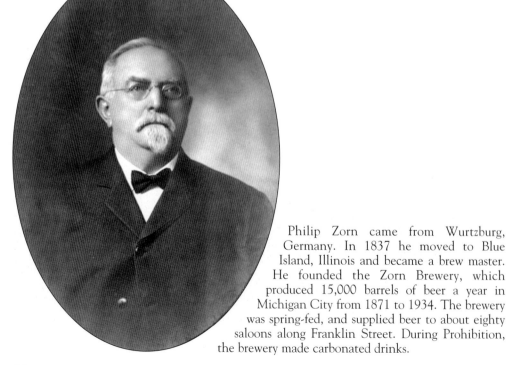

Philip Zorn came from Wurtzburg, Germany. In 1837 he moved to Blue Island, Illinois and became a brew master. He founded the Zorn Brewery, which produced 15,000 barrels of beer a year in Michigan City from 1871 to 1934. The brewery was spring-fed, and supplied beer to about eighty saloons along Franklin Street. During Prohibition, the brewery made carbonated drinks.

Northern Indiana Public Service Company's power plant stands in the background in this view of Michigan City. Samuel Insull, a Chicago millionaire, built the generating plant in 1929. The Northern Indiana Public Service Company was formed after Insull's empire collapsed during the Depression.

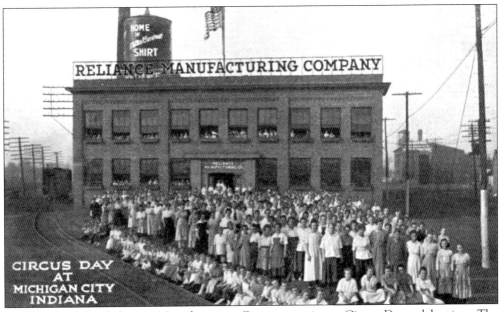

Employees of the Reliance Manufacturing Company enjoy a Circus Day celebration. The company made work shirts. Adults and children looked forward to summer Circus Days.

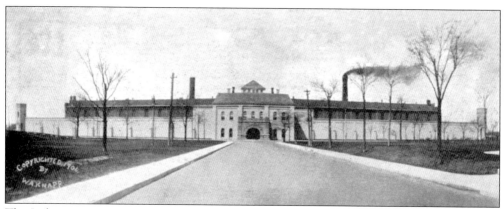

The Indiana State Prison was built in Michigan City to take advantage of the brick, lumber, and stone abundant nearby. Lake shipping and railroads entering the site from three directions also made it an ideal place for manufacturing and shipping. Cheap prison labor attracted many industries to Michigan City.

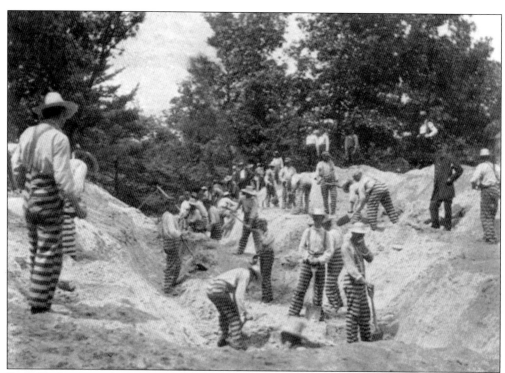

By 1938, the prison had 2,707 inmates. Convicts provided cheap labor for many Michigan City industries. They made furniture, hosiery, and gloves. A 1904 law banned the hiring of prison labor. By 1907, state institutions could manufacture goods for state consumption only.

Six

MIND AND SPIRIT

While waiting for their churches to be built, parishioners met and worshipped in schools, houses, and in some cases, tents. It was not unusual to meet in the basement of a church until the structure was finished. In 1894, Michigan City had fifteen thousand inhabitants. There were 11 churches and a convent.

The first pioneers came from the eastern states. The Irish came to work on the railroads as construction workers and operators. Germans who did not want to be conscripted left Hamburg and Bremen in the 1840s. Other ethnic groups came to work in the railroad car factories. These immigrants settled in their own communities and built their own churches. Swedish families settled in the west side of Michigan City. Catholic Syrians came to Michigan City in the early 1900s to work in the foundry of the Haskell Barker Car Factory. At one time, Michigan City had the largest Middle Eastern population in the U.S. The Asse El Jadeed Temple (The New Generation) was the first mosque built in the U.S. by Syrian and Lebanese Moslem immigrants.

The founder of Michigan City, Isaac Elston, donated a lot on the corner of Fourth and Pine Streets to build a small frame school. Gallatin Ashton was the school's first teacher. Elston was a Methodist, and he donated a lot to build a Methodist church. The captains of industry in Michigan City's 19th century were philanthropists who supported the arts, built churches, a library, a YMCA and an opera house. The Barker Mansion, home of industrialist John Barker is now the Michigan City Barker Civic Center. George Ames, a local businessman and philanthropist, gave his time and money to landscape the school grounds of the Central School. Ames also supported the Ames Band, and gave books and donated funds towards the creation of a public library.

Ames Field, the city's athletic field, is named for George Ames. Sports were popular in Michigan City and baseball was especially so. There were at least 16 uniformed baseball teams in Michigan City; among the town's teams were the Dolls Park Team, the Canada White Sox, the M.C. Zorns, the Grays, and the Cubs. Don Larson, a Michigan City native son, played for the New York Yankees. In 1956, he pitched the only perfect World Series baseball game, against the Brooklyn Dodgers.

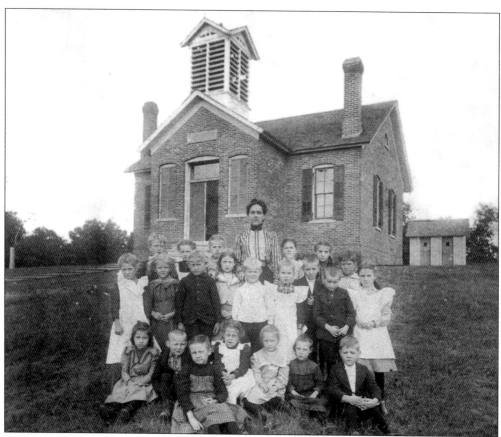

In this photograph of the Eastport School, pupils and their schoolmarm pose outdoors. The school was built in 1890 on East Michigan Boulevard. An outhouse with one stall for boys and one for girls stands to the right of the school.

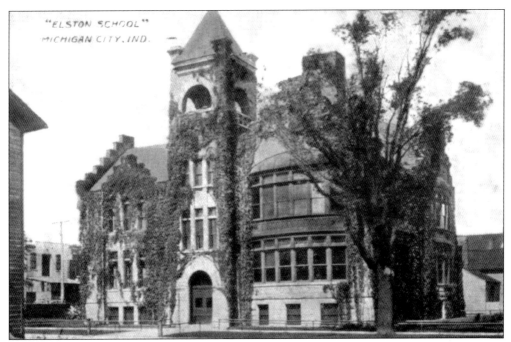

The ivy-clad Elston School was the high school named for the founder of Michigan City. It was built in 1909 on Detroit and Spring Streets. An addition was built in 1924, the year it became Elston Junior High School. The school was razed in 1980.

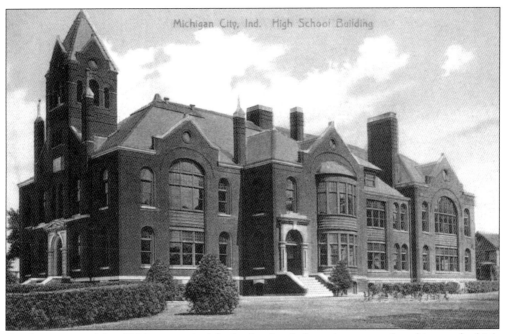

On the reverse of this 1908 postcard of the high school, the writer states that this was the high school and grammar school combined, with 1,500 students attending.

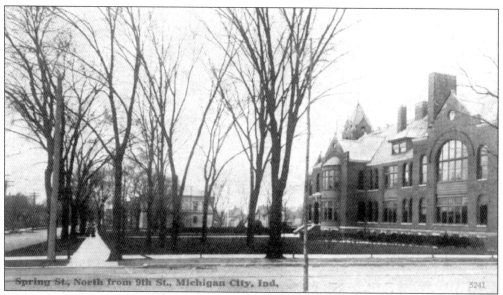

This is the Elston High School on Spring Street, looking north from Ninth Street.

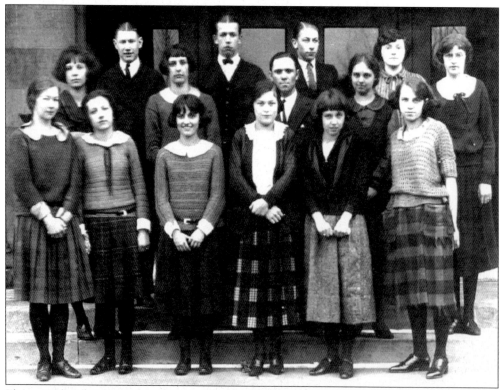

Elston High School graduates pose for this photograph taken in February, 1924. Pictured, from left to right, are: Richard Frame, Alden Schwikendorf, Art Phillips, Margaret Redpath, Charlotte Tyler, Marie Klinkenberg, Marion Johnson, Vance Geyer, Gladys Erickson, Gladys Bull, Eva Nelson, Alethea Kagels, Thelma Nelson, and Ethel Leusch. Gladys Bull Nicewarmer wrote *Michigan City, Indiana: The Life of a Town* in 1980.

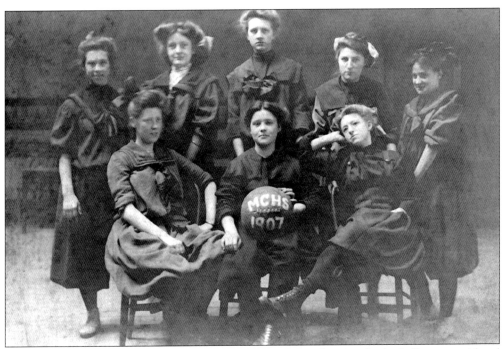

Here is the Elston Girls' Basketball Team in 1907. In its early years, basketball was considered to be a woman's sport.

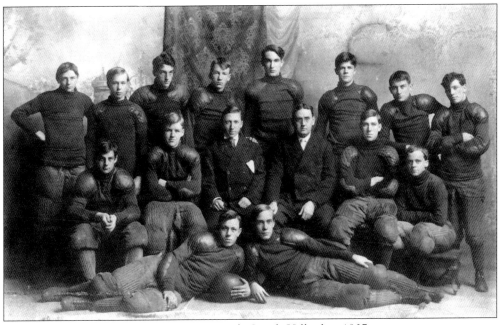

The Michigan City Football Team poses with Coach Hillard in 1907.

The congregation of the First Christian Church originally assembled in a tent in 1907. The first permanent church was built in 1910 on Pine Street, followed by this second church on Cedar Street, begun in 1925 and completed in 1939.

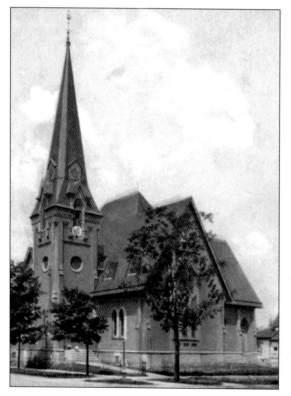

Many of the area's first settlers were from New England, and a Congregation was formed in 1825. The Congregational Church, built in 1835 on the northwest corner of Sixth and Washington Streets, stood where the new Michigan City Library is located.

The Nourse and Allen company was a knitting mill in the building that once housed the First Methodist Church on Fifth and Cedar Streets. It was the first factory in Michigan City to hire women. The Methodist Church took out a permit to build this church on Pine and Seventh Streets in 1921.

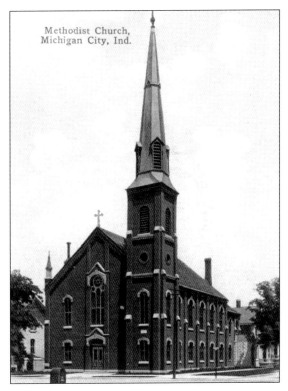

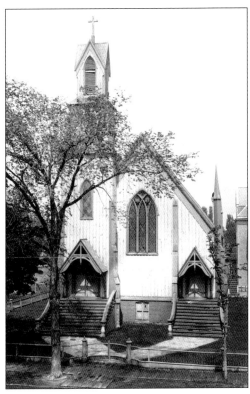

The first Episcopal Church was a wood-frame Gothic-style building, completed in 1858.

The cornerstones of the Trinity Episcopal Church date to 1836. Here, the Bishop presides as the foundation stones are laid.

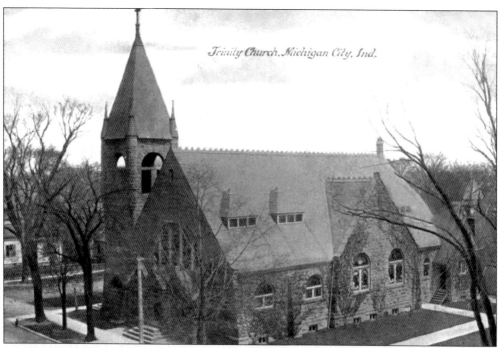

The Trinity Episcopal Church is a Romanesque-style stone building completed in 1889. John H. Barker contributed to its cost. Following its completion, the church served as the cathedral for the Northern Diocese of Indiana for several years.

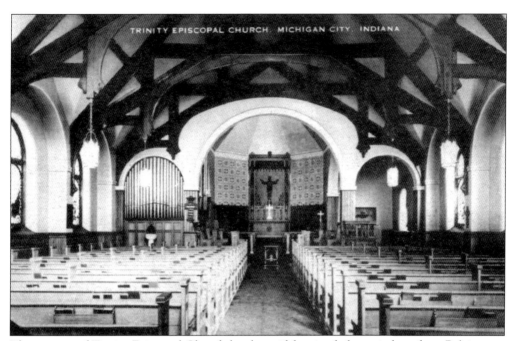

The interior of Trinity Episcopal Church has beautiful stained glass windows from Belgium.

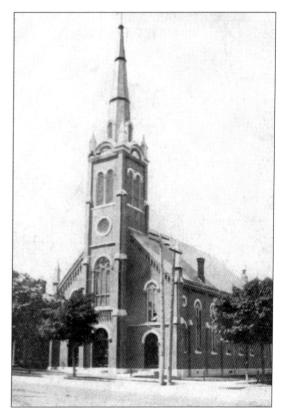

This is St. John's Church in 1909. The German United Evangelical Lutheran Church, St. John's Congregation, became a parochial school. From 1882 to 1889, it was home to the William Mellor and Son Knitting Mill. The steeple was destroyed when it was hit by lightning in 1899, and the building was condemned and razed in 1915. The Canterbury Theater, a summer stock theater, occupies the current building.

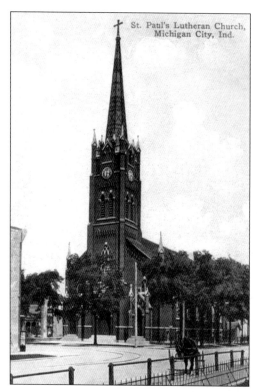

St. Paul's Church is one of the oldest churches in Michigan City. It was built in 1876 after the minister and part of the congregation of St. John's Church had religious disagreements. It was said that members of both churches interrupted each other's services by pouring water into the church basement windows. St. Paul's Church is taller than St. John's and has a clock in its steeple.

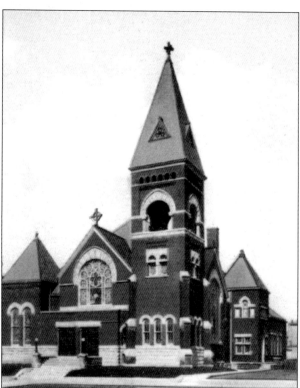

The First Presbyterian Church is located at 121 West Ninth Street.

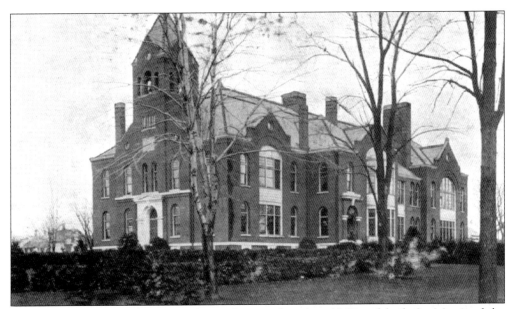

The two Catholic parishes in Michigan City combined in 1867 and built St. Mary's of the Immaculate Conception Catholic Church. This is how St. Mary's Church looked in 1869. The church, on the southwest corner of Washington and Fourth Streets, was built in 1859 and is one of the oldest churches in Michigan City. It has been extensively remodeled. Its parishioners were mainly German and Irish.

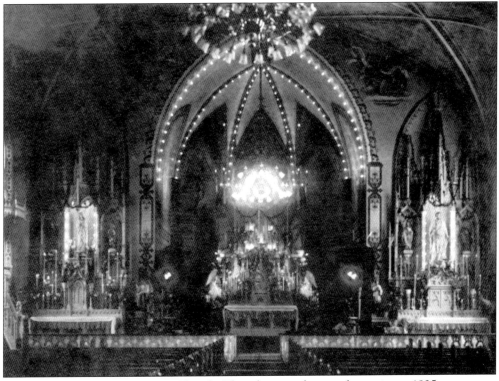

This is the interior of St. Mary's Church. This photograph was taken prior to 1925.

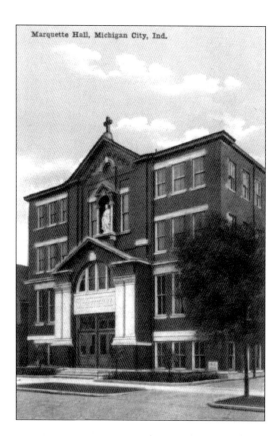

Marquette Hall was built in 1914, with an auditorium to provide recreational facilities for St. Mary's Church.

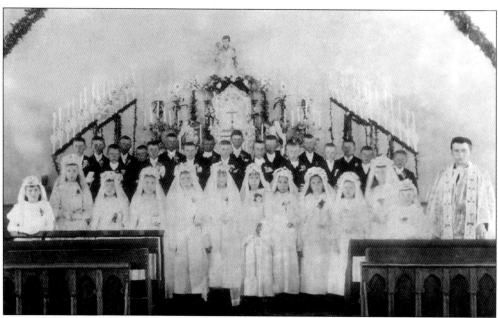

This is the interior of St. Stanislaus Kostka Church. The children prepare to make their first communion. Father Emmanuel Wrobel, far right, formed a Polish Catholic Congregation in 1891.

Seven

MICHIGAN CITY BECKONS YOU

Michigan City, Indiana, a booklet published by the chamber of commerce in the 1920s, boasted: "The resorter at Michigan City is out in the refreshing atmosphere and surroundings of the country and yet within a few minutes ride of all the city's attractions and activities. Michigan City is becoming known as the 'Atlantic City of the West.'" John Barker donated a band shell for Washington Park, and the Peristyle, a Greek Revival building that was a copy of a building at the Columbian Exposition in Chicago. George Ames supported the Ames Band, which played in the park on Sundays.

The Redpath Chautauqua, an important cultural event that spread across the country from New York, pitched its tent near the lighthouse, close to the bend of the harbor, in the Elston School playground or at the Central School. Tickets were sold door-to-door. This organization brought lectures, plays, and musical events to Michigan City in the summer.

Judging by the messages written on the backs of the many postcards mailed from Michigan City, visitors were enthusiastic about it and urged their friends to join them for fun in the surf and sand. "I wish you could see the fine colony here on the water," wrote one visitor.

In 1909, Frank Boeckling, the superintendent of the South Shore Amusement company, brought half-a-million visitors to Michigan City. The Indiana Transportation Company brought 275,000 more. The steamer *Wisconsin* ferried 1,700 passengers in two trips. The South Shore Line carried 50,000 riders, and around 10,000 drove into town. Frank Boeckling was the son of John Boeckling, who owned a grocery story at 710 Franklin Street. On August 8, 1909, a crowd of 18,000, the largest number on a single day, arrived in Michigan City for the field exercises of the Woodmen of the World.

In 1913, the city council signed a contract with the South Shore Amusement company to operate a dance floor, a skating pavilion, a bath house, and a narrow gauge steam train. The amusement area had a roller coaster, a merry-go-round, shooting galleries, and many food and drink concessions.

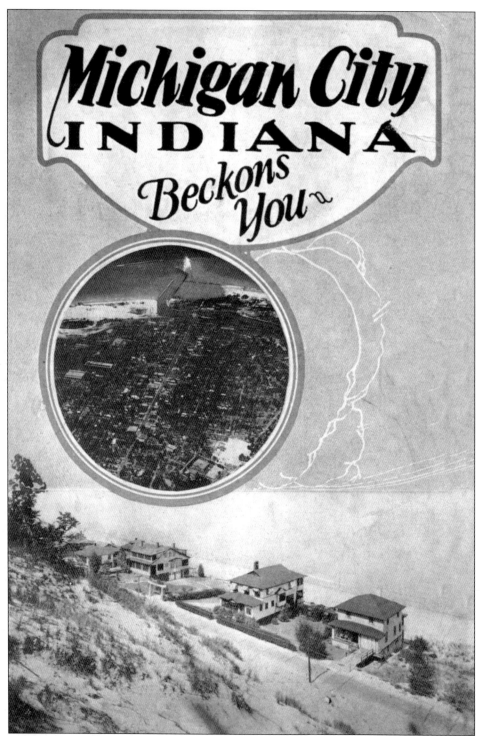

"Michigan City Beckons You," from the cover of a promotional brochure, showcases Michigan City, the beach, and lakefront cottages. At the turn of the century, a number of cultural, religious, and entertainment activities attracted visitors who arrived by excursion boat and train.

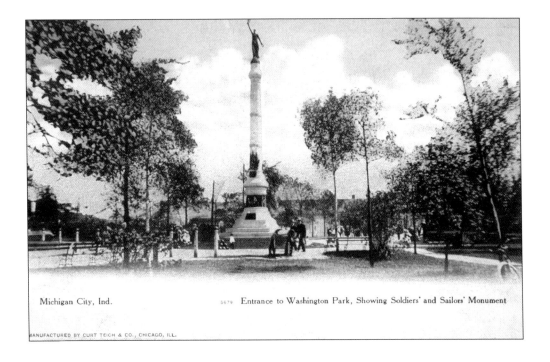

Michigan City, Ind. 6679 Entrance to Washington Park, Showing Soldiers' and Sailors' Monument

MANUFACTURED BY CURT TEICH & CO., CHICAGO, ILL.

The Soldiers and Sailors Monument greets visitors at the entrance to Washington Park. In 1896, John Winterbothom donated the funds to build this Civil War memorial. The monument had two cannons that were donated to supply metal to the war effort in 1942.

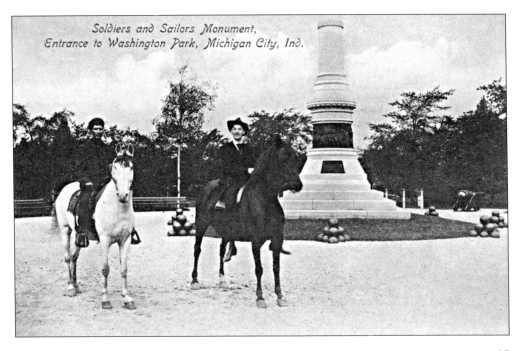

Soldiers and Sailors Monument, Entrance to Washington Park, Michigan City, Ind.

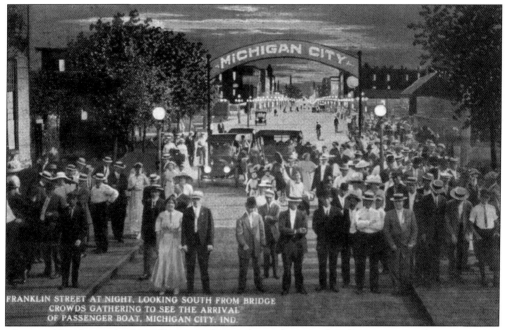

The Franklin Street Arch is illuminated at night as the crowd gathers to meet passengers.

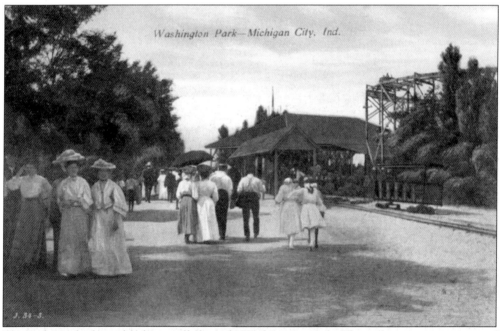

These elegantly dressed ladies stroll through Washington Park. The roller coaster was one of the park's many attractions. Michigan City was sometimes referred to as "The Coney Island of the West" because it had a bathing beach, a roller coaster, a whirling swing, a narrow gauge railroad, and souvenir shops and concessions.

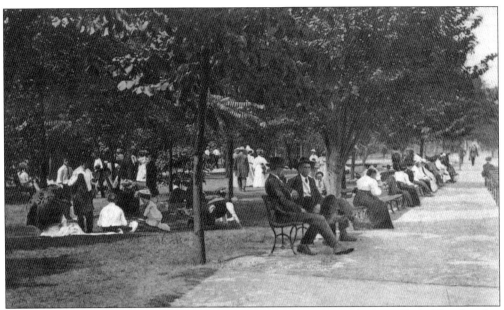

Both residents and tourists enjoyed strolling and picnicking in Washington Park. The chamber of commerce promoted the park and its many amusements as the "Atlantic City of the West."

Greetings are sent from a grove in Washington Park. The back of this postcard describes it as an ideal place to hold a picnic. It reads: "One of the picnic shelters where you may eat an enjoyable picnic lunch in beauty and comfort."

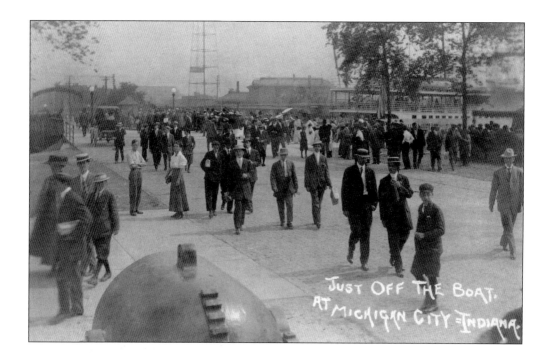

Many tourists arrived in Michigan City by steamer. This group is just off the boat and headed to Washington Park. Excursion ships from Chicago brought thousands of visitors to Michigan City from the 1890s through the early 1900s. The steamer *America* ran two daily excursions from Chicago.

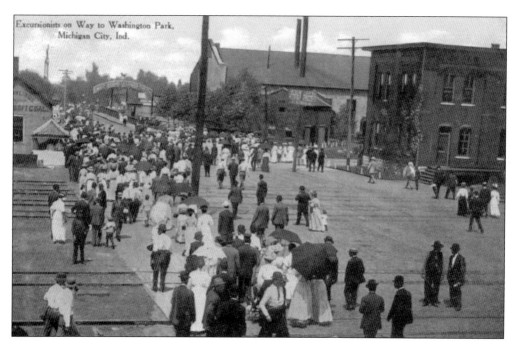

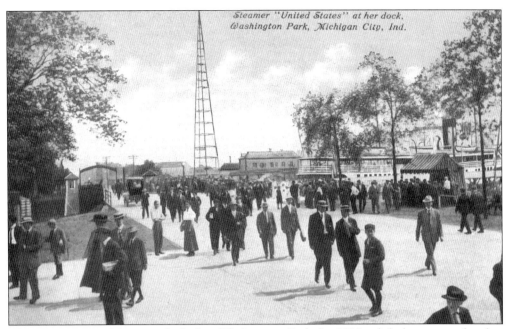

The steamer *United States* is docked at Washington Park. In 1910, while being towed to her berth, the ship backed into the Franklin Street Bridge and collapsed it. The *United States* returned to Chicago the same day.

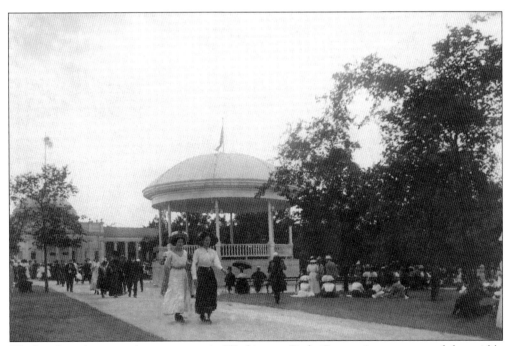

The bandstand was another attraction in Washington Park. George Ames supported the weekly Sunday band concerts in July.

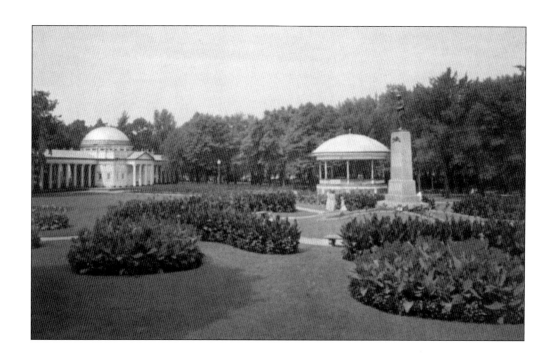

Industrialist John H. Barker paid for the peristyle and the bandstand in Washington Park.

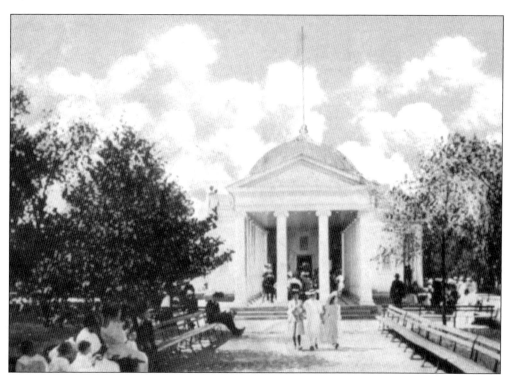

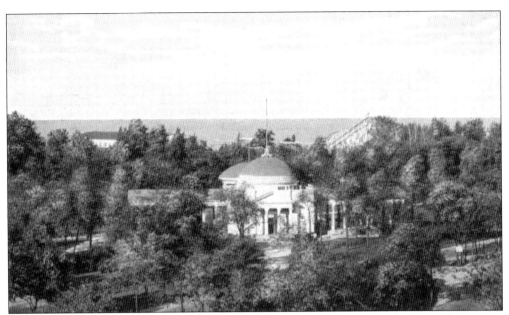

Here is Washington Park at the height of its glory with the bathing beach, the roller coaster, the dancing pavilion, and the peristyle.

This souvenir postcard is from Max Bodine's Postcard Studio and is dated July 5, 1909. The writer informs us that "Miss Weis, my roommate is in the middle. Had a beautiful day and a fine time."

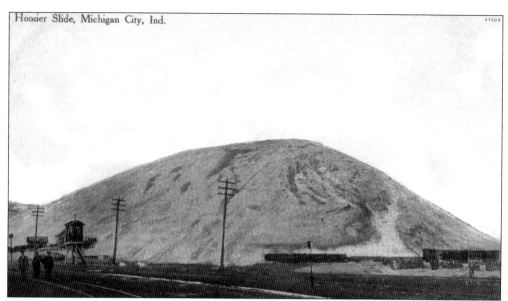

The Hoosier Slide was a 200-foot dune that proved to be a popular attraction and a place to hold weddings. Famous visitors included Daniel Webster and President McKinley, who was honored with a twenty-one gun salute fired from the top. A visitor to the Hoosier Slide wrote, "It is a wonder you just can't write about. This is the sand hill that is nine miles around. I have not yet attempted to climb it." The Hoosier Slide continued to be Indiana's most famous landmark until it was mined for glassmaking and landfill. Visitors arrived by train, climbed up the hill, and slid down it. Free weddings were promoted. The bride and groom were given complimentary transportation, a free marriage license, and the services of a minister.

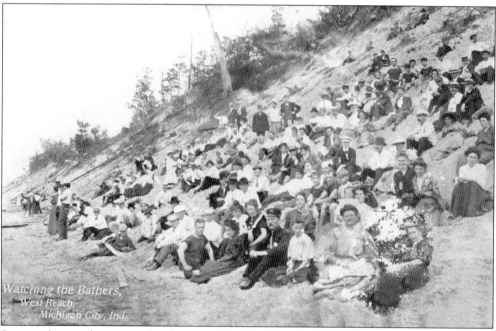

Sun worshippers lounge on the dunes of West Beach and watch the bathers enjoy themselves in the surf.

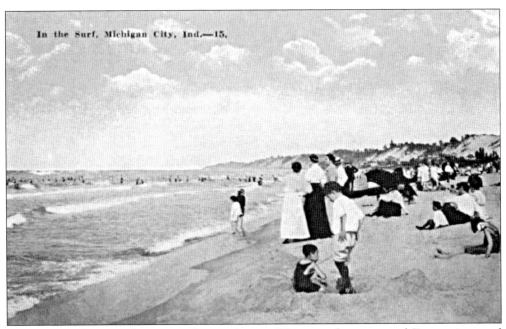

The person who sent this postcard wrote home, "Having a fine time and I'm getting good and brown."

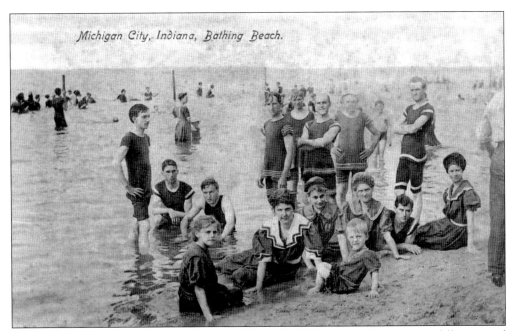

The West Beach offered "Acres and acres of glistening Singing Sands where sun followers and swimmers can relax and play."

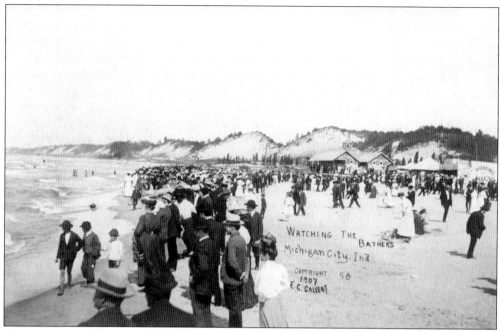

This postcard of the bathing beach and its bathhouse was made by the Calvert Studios in Michigan City in 1907. Earle Calvert ran his studio from 1889 to 1937 and owned one of the earliest cameras in Michigan City.

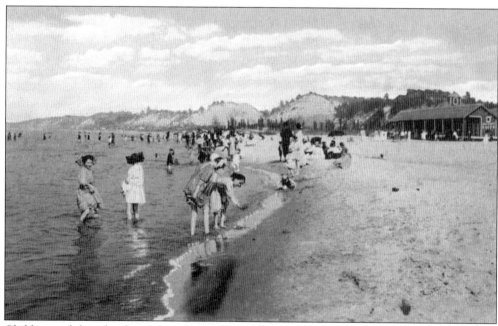

Children and their families enjoy a day at the seashore and hunt for treasures at the water's edge.

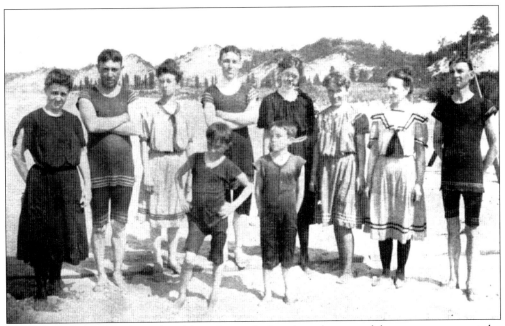

This group, appropriately outfitted for a day at the beach at the turn of the century, poses at the water's edge.

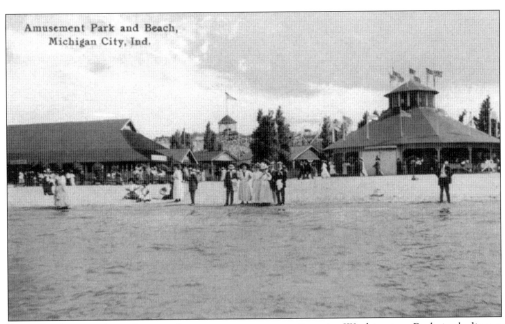

In 1913 the city leased space for amusement concessions in Washington Park including a bathhouse, shooting galleries, a merry-go-round and a dance pavilion.

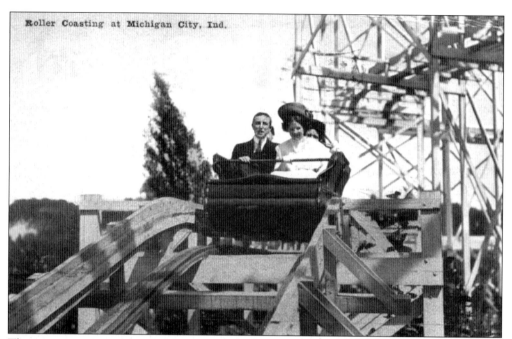

Roller Coasting at Michigan City, Ind.

These visitors to Washington Park enjoy a thrilling ride on the Roller Coaster.

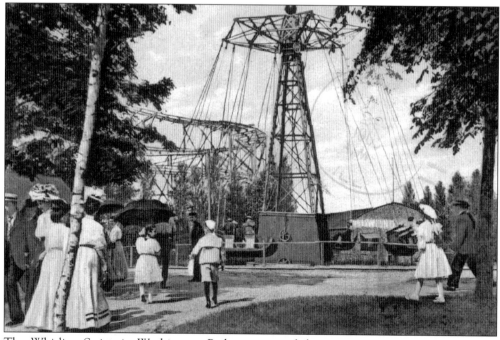

The Whirling Swing in Washington Park was one of the many amusements that brought families to Michigan City and Washington Park.

During the 1930s a group of modest tourist cabins was built in the park west of Yankee Slide. This family enjoys a picnic outside one of the cabins.

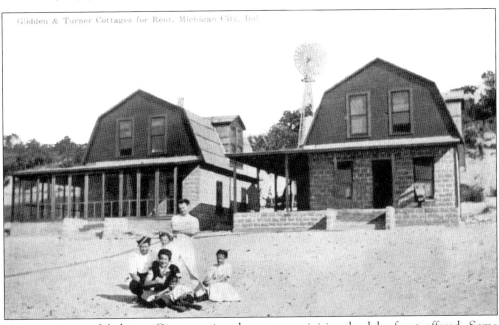

Visitors came to Michigan City to enjoy the many activities the lake front offered. Some "excursionists" came to spend the day, but others spent weekends or part of the summer in Michigan City and lived in hotels, rented cottages, or pitched tents. Glidden and Turner offered cottages for rent.

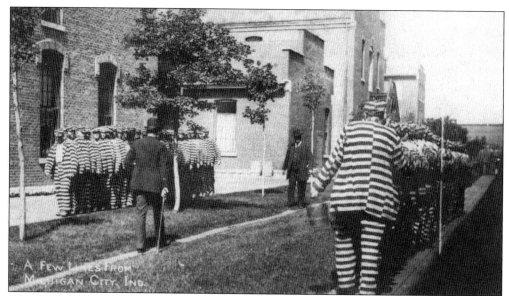

Although the prison contracted the labor of its inmates to industry and contained factories within, it was also a tourist attraction for many visitors to Michigan City. A trip through the prison cost 25 cents. A train pulled up to the prison gate and dropped off the tourists.

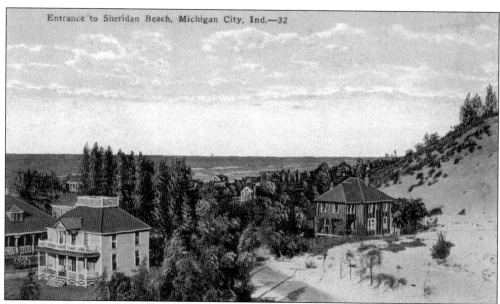

This is the entrance to Sheridan Beach, a resort community east of Washington Park. The first cottage belonged to Oscar A. Wellnitz, who built his beach house here in 1905. Lakefront cottages became fashionable. William B. Manny and Isidore J. Spiro bought the land to build Sheridan Beach in 1907. Before 1918 most cottages along the lakefront were the summer homes of local citizens. When Wellnitz built his beach cottage, he was considered eccentric for wanting to live in the windswept dunes, and the idea of building houses in the sand did not make sense to people. But soon wealthy Chicago families built cottages along the sandy lakeshore, and during the depression of 1929 some Chicagoans gave up their houses in the city and moved to their summer homes permanently.

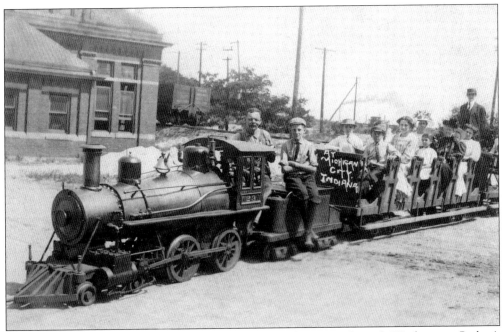

The Miniature Train, a narrow gauge steam train, took visitors through Washington Park. A youngster who rode this train wrote on the back of this postcard, "I rode this train. Am having a good time."

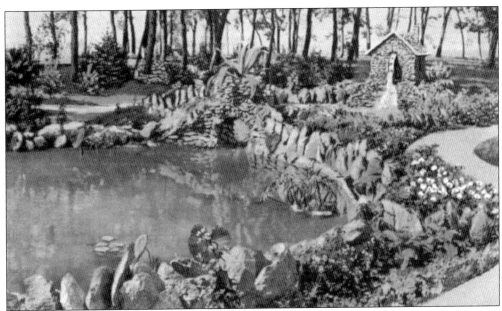

The Rock Gardens, the Hillside Flower Gardens, and sand dunes made a nice background for the zoo animals in Washington Zoo.

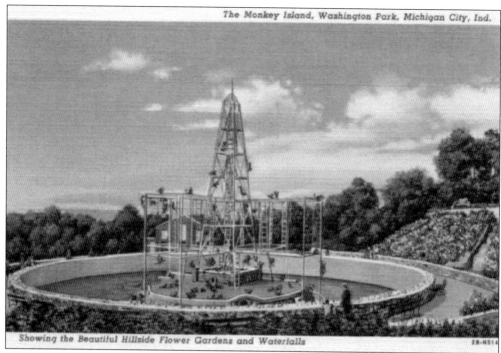

Showing the Beautiful Hillside Flower Gardens and Waterfalls

The Monkey Island in Michigan City's Zoo was set among The Hillside Flower Gardens and Waterfalls. Visitors watched hundreds of monkeys cavort here. The zoo had buffalo, "Cuddles" (the baby elephant), and over 300 other animals and birds.

In a cartoon postcard of The Monkey Island, the monkeys take a dim view of their human observers. On the reverse of the postcard the poem reads:

> The monkeys on the island you see
> Discussing things as they're said to be.
> Said one, now listen you,
> There's a rumor that can't be true,
> That man descended from our race;
> The very idea is a disgrace.
>
> No monkey ever deserted his wife
> Starved her babies and ruined her life.
> And you never knew a mother monk
> Leave her babies at home alone to bunk
> Or pass them on from one to another
> Till they scarcely know who is their mother
> Another thing a monk won't do,
> Go out at night and get on a stew.

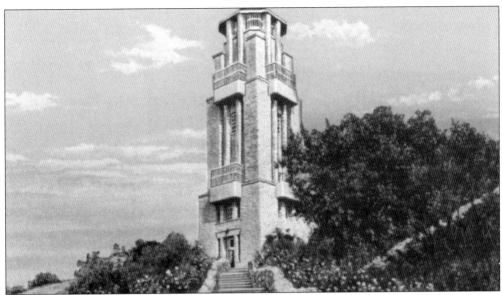

The Observation Tower in Washington Park overlooks Lake Michigan and is one of Michigan City's most recognized landmarks. The tower was built in 1936 by the Works Project Administration. WPA workers took a framework discarded by the South Shore Railroad and faced it with limestone. In 1934, 5,000 schoolchildren planted 10,000 pine trees on the dune it sits on, restoring the land to its original vegetation. The tower's roof ornament was the compression chamber from Michigan City's first fire engine. Beginning in 2005, the tower will undergo a $660,000 restoration.

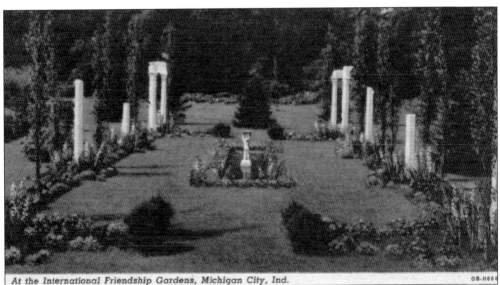

At the International Friendship Gardens, Michigan City, Ind. OB-H66

The International Friendship Gardens were established in 1934 following the 1933 Century of Progress Exposition in Chicago. The collection of gardens was dedicated to world peace and covered over 100 acres of rich alluvial soil in the Trail Creek valley. Its mission was to create a botanical environment that promoted world friendship through ethnic gardens, and to enhance the lives of visitors through artistic, musical, and nature-related educational opportunities. This is the Italian Gardens.

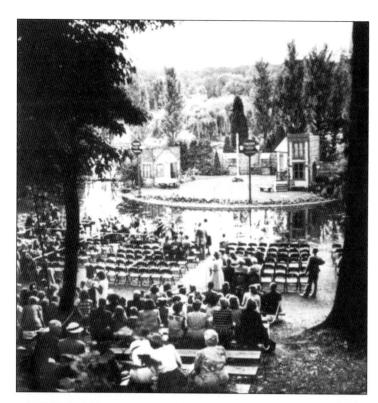

Two outdoor theaters were created in the gardens: The Little Symphony Theater and The Theater of Nations. The latter was built on a small island in a small lake. The still waters of the lake reflected the actors. The audience sat on the opposite shore of the lake on an adjoining hillside that forms a natural amphitheater. The International Friendship Gardens was the home of the Chicago Musicland Festival, which put on plays such as *A Midsummer Night's Dream* and *Evangeline*.

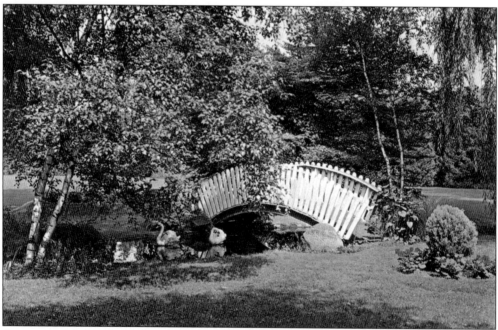

Swans swim under the Willow Bridge in the Friendship Gardens. The gardens drew visitors from all over the world who enjoyed its flowers, mazes, and music festivals. The gardens are still open May through October. Marquette Spring, near the Friendship Gardens is named for Father Marquette, a Jesuit missionary who preached to a group of Pottawatomie Indians here.

Eight

AN ALL-AMERICAN CITY

The first log cabin in Michigan City was on the southeast corner of Fifth and Franklin Streets. Willys Peck was elected the city's first mayor on April 12, 1836. He served as mayor for one year. Samuel Miller, who became Elston's land agent, served the next one-year term. Miller arrived in Chicago in 1825 and married Elizabeth Kinzie, John Kinzie's daughter. On her death in 1832, he moved to Michigan City.

Immigrants who arrived in Michigan City in the late 1800s and early 1900s established their own neighborhoods and built their own churches. Much of what remains of old Michigan City lies along the 400 block of Franklin Street. The high Victorian Italianate buildings were built in the 1870s. The best example of this style is St. John's Hall (St. Johannes Verein), built by German immigrants.

In 1836, the year Michigan City was incorporated, Major Elston donated a lot at the corner of Fourth and Pine Streets for a school. A small frame school was built and Gallatin Ashton became the first teacher. The same year, Elston, who was a Methodist, donated a lot to build a Methodist church.

The 1840 diary of a farmer reveals the daily activities and the communal life of early settlers, which included singing school, prayer meetings, quilting bees, revivals, weddings, spelling bees, candle dippings, sugar making, temperance meetings, log rollings, sleighing, and hunting.

The merchants who lived in the "Silk Stocking District" entertained lavishly and made sure that visitors were made to feel welcome. A select group of young men sponsored charitable and social events. A Woman's Study Club met at Mrs. Allen Sammon's home. The idea to organize a historical society began in 1923.

In 1966, Michigan City was one of thirteen cities designated as an All-American City and cited in *Look* for the quality of its community life and its citizen action programs.

Mayor Martin Krueger lived in this house where Scott's Mill once stood. Scott's Mill was a grist mill completed in 1834, one of the earliest settlements in this part of the state.

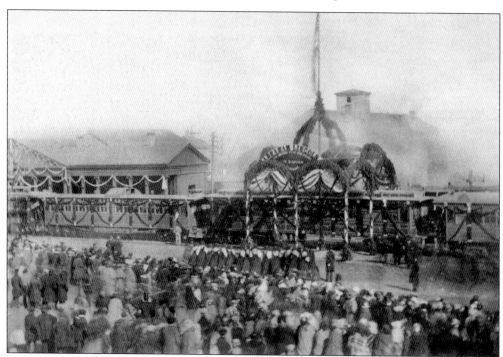

President Abraham Lincoln's funeral train stopped in Michigan City on its way from Chicago to Springfield, Illinois. On May 1, 1865, the Michigan Central Railroad halted beneath a 35-foot memorial arch, and the people of Michigan City paid their respects.

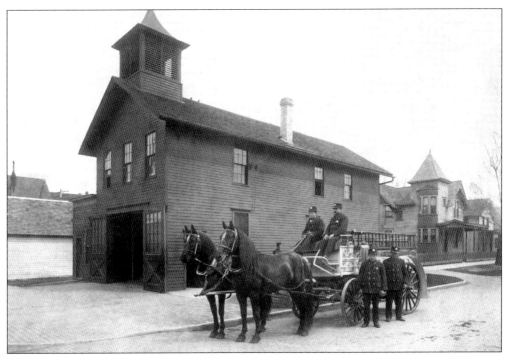

Four Michigan City firemen are shown with a horse-drawn pumper. By 1904, Michigan City had a paid fire department. The City took over two volunteer stations at Tenth and Franklin Streets and on Fourth Street.

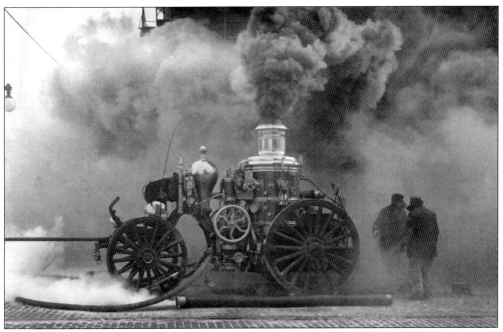

Engine #1 was a steam pumper, bought in 1883, that served the city well until it was donated to the prison in 1930. Alarm boxes were installed in 1887. The compression chamber from this engine became an ornament that was placed on top of the observation tower.

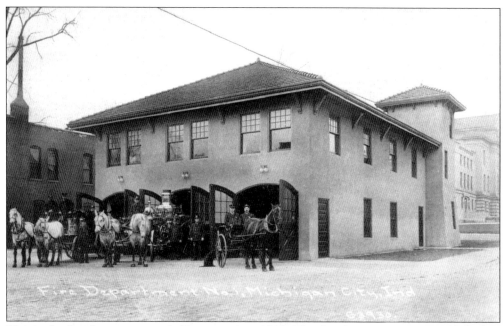

This is the fire department with Pumper # 1 in 1919. The fire department was established in 1837. In 1883, the city purchased its first steam engine, "Protection." Alarm boxes were installed in 1887.

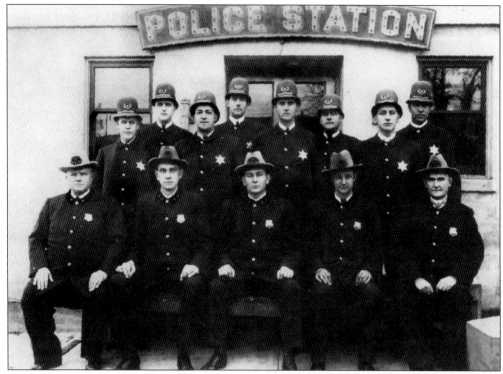

This is Police Station #8. The first police department was started in 1879. Until then, town marshals kept law and order.

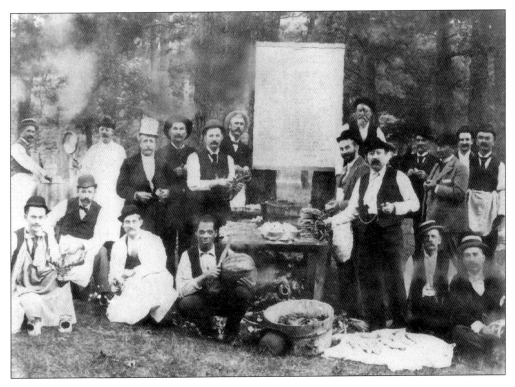

This clambake was held in Washington Park on Labor Day, 1893. Charles Porter was the chef and master of ceremonies. The placard lists the chores he assigned to the participants: set table, husk corn, open clams, split lobsters, strain tomatoes, and cut potatoes. The ladies relax and wait for the food to be served.

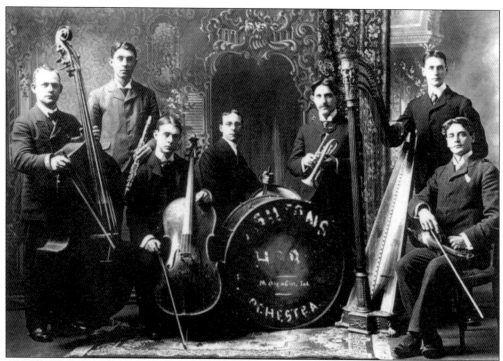

This is a photograph of the Ashton Harp Orchestra and its members, *c.* 1910.

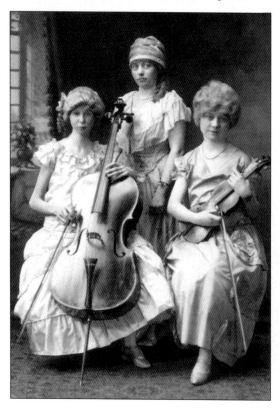

Joy Carson is in the center of this musical group. Performing in musical and singing groups and attending these performances were popular hobbies and pastimes.

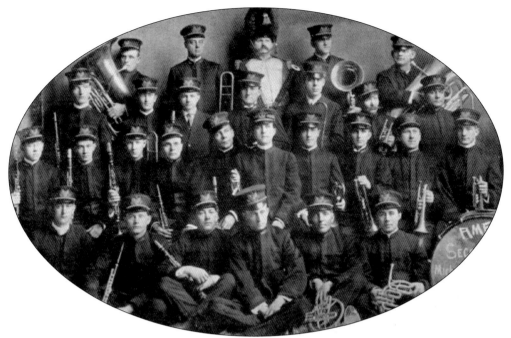

The Ames Second Regiment Band was organized in1869 as a drum and bugle corps. The band played in many concerts on the lakefront and was named for George Ames, who took an interest in the group. Municipal band concerts are still scheduled weekly from June through August.

The White Sox baseball team poses for a photograph taken in 1914. Michigan City had no fewer than 16 uniformed semi-professional baseball teams.

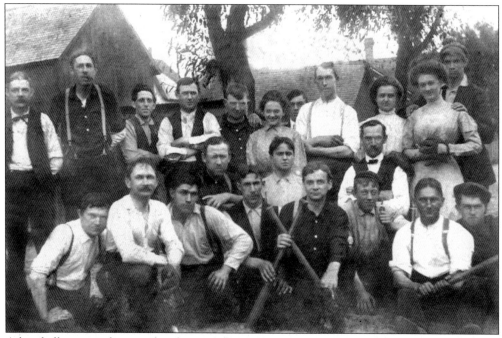

A baseball team and some of its fans pose here.

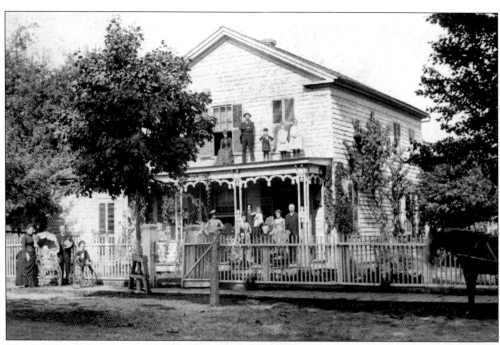

The gang's all here at the Couden house in 1888. Wood and iron fences were a necessity. According to one resident, people kept pigs and chickens in their yards, even in town. "Everyone used to have fences in town to keep marauding cows and pigs out of their yards. Everyone had chickens and a garden. Pigs were common and many families had cows."

This house has a wraparound porch. Most houses were built with porches where residents watched passersby and socialized.

This photograph of a group near a fallen tree was taken in front of 216 East Sixth Street.

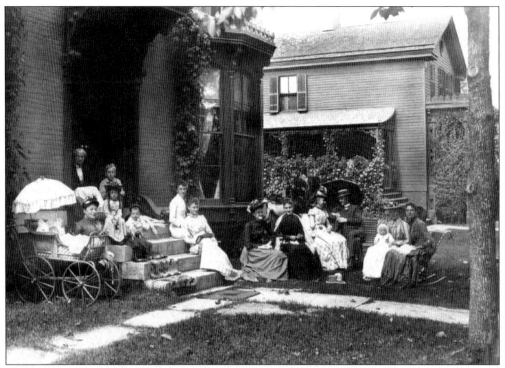

Families enjoy a pleasant day on the steps and in the front yard of the J. Orr house.

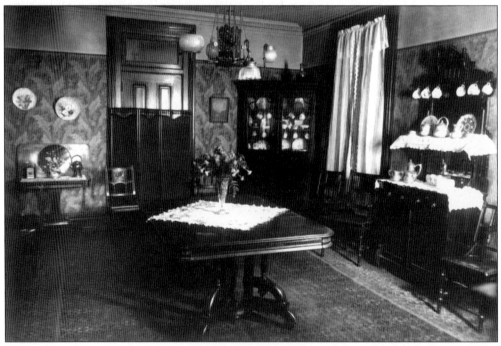

This is how the interior of Minnie Leeds's parlor looked, c. 1900. A Michigan City resident reports in an oral history that most houses had a parlor—reserved for guests, funerals, and weddings—and a sitting room where the family lived.

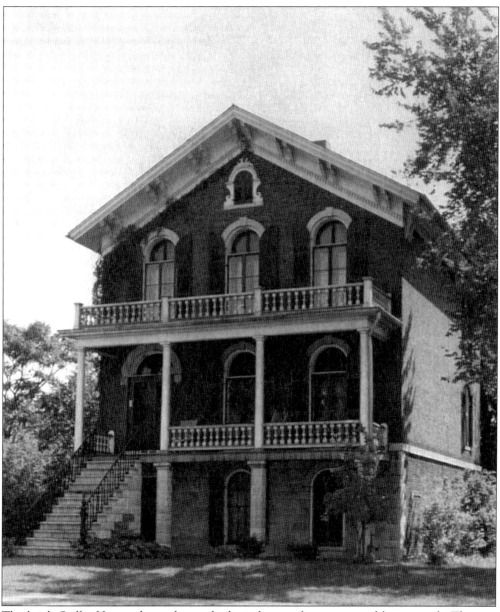

The brick Otillia Hansen house has arched windows and an upper and lower porch. This is a picture of the house taken in 1935. Wooden houses were more common than brick homes.

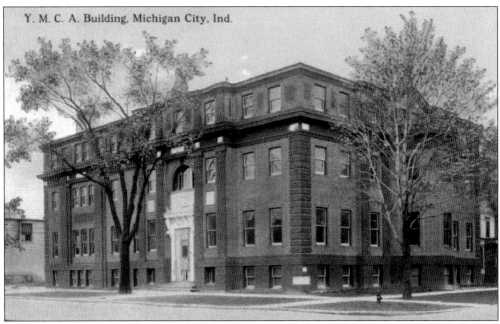

Y. M. C. A. Building, Michigan City, Ind.

John H. Barker first proposed building a YMCA in 1907. A fund drive was held at the Grand Opera House. Barker gave half of the $60,000 raised. The YMCA opened in 1912 and moved into a new building on East Coolspring Avenue in 1974.

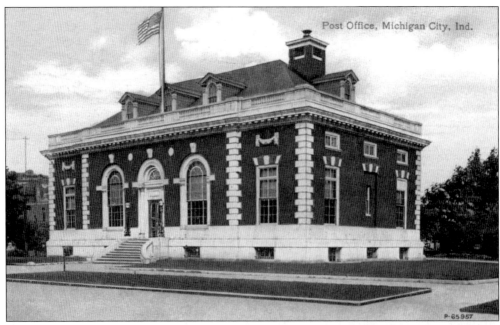

Post Office, Michigan City, Ind.

The old Post Office stood on the corner of Fifth and Pine Streets. Samuel Miller, Michigan City's first settler, was also its first postmaster. Before Miller established the post office, mail was carried by Native Americans and soldiers. Miller started a horseback service to La Porte and a stage line to South Bend.

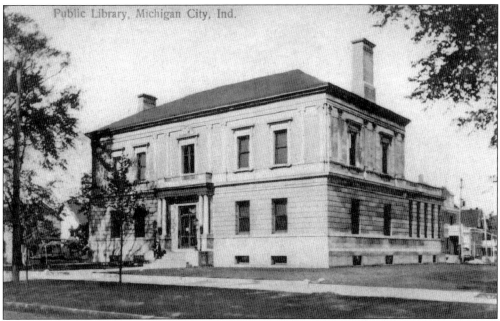

This is the old public library. George Ames willed his large personal library to the town, along with an additional $5,000 to buy books for a public library. John H. Barker agreed to donate one third of the total cost, estimated at $25,000, to fund a library, if citizens agreed to raise the rest. The new public library, designed by Helmut Jahn is on Fourth Street. It opened in 1977 and is home to a permanent art collection of over 85 works, including paintings, prints, sculpture, and posters of local and regional interest.

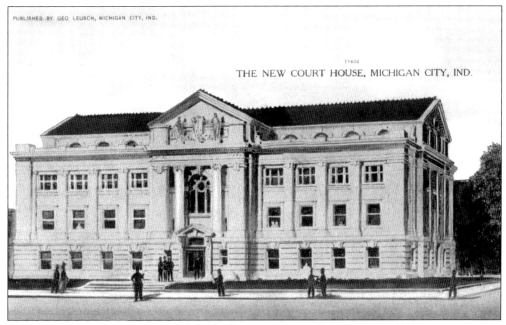

Pictured here is the courthouse as it looked in 1915. This postcard was made by George Leusch, who owned an ice cream parlor and a novelty shop downtown.

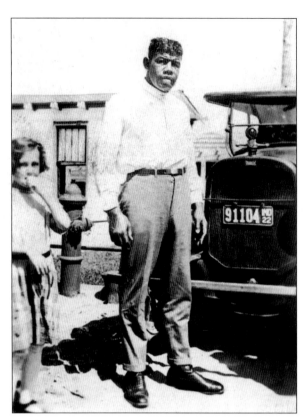

Jack Johnson was the first black heavyweight champion. In 1910, Herman and Bill Brinkman, who owned a livery station on Franklin Street, fixed Johnson's flat tire.

On Arbor Day in 1934, this group of students planted trees on Yankee Slide. Five thousand school children planted 10,000 pine trees in an effort to restore the dune to its original vegetation.